# Mastering the Watercolor Wash

***Rising Tide***
Watercolor on 140-lb.
(300gsm) cold-pressed Arches
11" x 29" (28cm x 74cm)

# Mastering the Watercolor Wash

### Joe Garcia

**NORTH LIGHT BOOKS**

www.artistsnetwork.com
North Light Books
Cincinnati, Ohio

## About the Author

Native Californian Joe Garcia lives and works near Julian, California, where the forest of oaks and pines shelter an abundance of birds, deer and other wildlife. It is an area of varied landscapes and a perfect setting for an artist who specializes in painting those subjects.

Joe earned a Bachelor of Fine Arts degree with an advertising/illustration emphasis from the Art Center College of Design in Los Angeles in 1970. He worked as an illustrator and graphic designer for 13 years, during which time he spent his free hours honing his watercolor painting skills. Since 1983 Joe has painted full-time, leaving the commercial work behind. He generally portrays his subjects in a tight, yet delicate center of interest, complemented by a loose, interpretive background. In recent years Joe's direction has included more complicated, controlled compositions. He also has expanded his choice of media to oil paints, working on location and in the studio. His original paintings and prints may be found in galleries and private collections throughout the United States and Canada.

*Mastering the Watercolor Wash.* Copyright © 2002 by Joe Garcia. Manufactured in China. All rights reserved. No part of this book may be reproduced in any form or by any electronic or mechanical means including information storage and retrieval systems without permission in writing from the publisher, except by a reviewer who may quote brief passages in a review. Published by North Light Books, an imprint of F&W Publications, Inc., 4700 E. Galbraith Road, Cincinnati, Ohio, 45236. (800) 289-0963. First Edition.

Other fine North Light Books are available from your local bookstore, art supply store or direct from the publisher.

06   05   04   03   02     5   4   3   2   1

Library of Congress Cataloging in Publication Data
Garcia, Joe,
    Mastering the watercolor wash / Joe Garcia.— 1st ed.
        p. cm
    Includes index.
    ISBN 1-58180-167-X
    1. Watercolor painting—Technique I. Title.

ND2430 .G37 2002
751.42'2—dc21
                    2001044407

Edited by James A. Markle
Designed by Lisa Buchanan
Production art by Lisa Holstein
Production coordinated by John Peavler
Cover photography by Guildhaus Photographics

### Metric Conversion Chart

| To convert | to | multiply by |
| --- | --- | --- |
| Inches | Centimeters | 2.54 |
| Centimeters | Inches | 0.4 |
| Feet | Centimeters | 30.5 |
| Centimeters | Feet | 0.03 |
| Yards | Meters | 0.9 |
| Meters | Yards | 1.1 |
| Sq. Inches | Sq. Centimeters | 6.45 |
| Sq. Centimeters | Sq. Inches | 0.16 |
| Sq. Feet | Sq. Meters | 0.09 |
| Sq. Meters | Sq. Feet | 10.8 |
| Sq. Yards | Sq. Meters | 0.8 |
| Sq. Meters | Sq. Yards | 1.2 |
| Pounds | Kilograms | 0.45 |
| Kilograms | Pounds | 2.2 |
| Ounces | Grams | 28.4 |
| Grams | Ounces | 0.04 |

## Dedication

I dedicate this book to my wife, Anne, for her encouragement, love and support and to my son, Jason, a very talented special person.

*Gator Path*
Watercolor in 80-lb.
(170gsm) cold-pressed Liberte
watercolor sketchbook
8" x 10" (20cm x 25cm)

## Acknowledgments

Writing a book must be a little like having a baby. It takes a lot of push and pull and a great deal of team effort. I know the pain is not the same, but my editor kept saying, "Take two aspirin and call me in the morning." I cannot say I would want to go through this again, but then ask me again in two years!

With all this said and done, I must express special appreciation to the many family members and friends who make painting such a joy, and to the many collectors who encourage me and enjoy my work. They make the road a little less bumpy.

Special thanks to Anne. She translated pages of graffiti to the computer, and without her ability to unravel the mysteries of my writing, this book would still be a concept.

Thank you to Adele Earnshaw, whose ideas and friendship have helped me set goals in my work.

Thank you to Don Darrock, whose photographic talents were put to the test. I appreciate his skills. Now, if I could only get him to paint!

Acknowledgments would not be complete without saying thank you to all the students in my watercolor classes. They laughed at my jokes and pretended to believe I knew what I was talking about. They made this book a much easier project than it would have been otherwise.

Special thanks and acknowledgment are given to my editors, Rachel Wolf and Jamie Markle. I appreciate their time, effort and patience. With calm, reassuring assistance they pulled me through the maze.

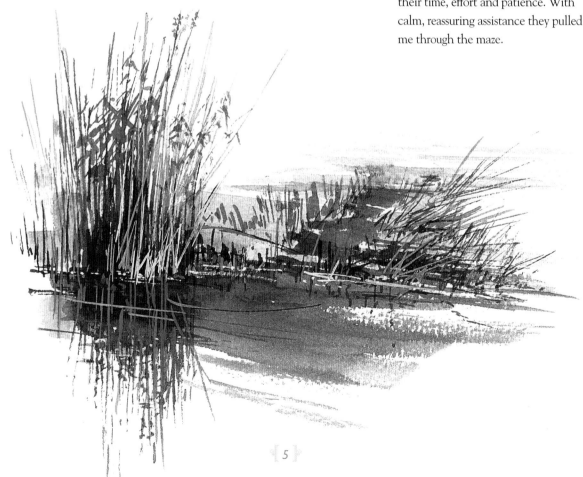

# Table of Contents

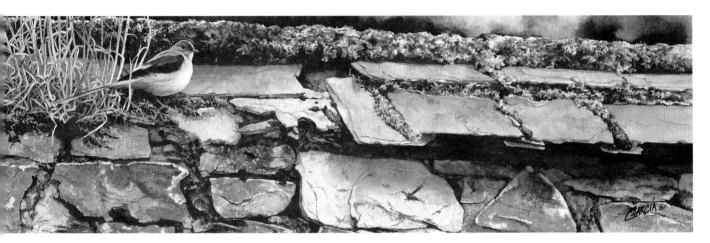

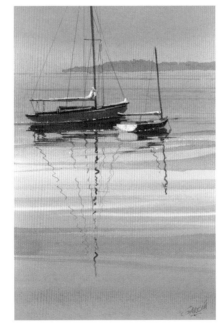

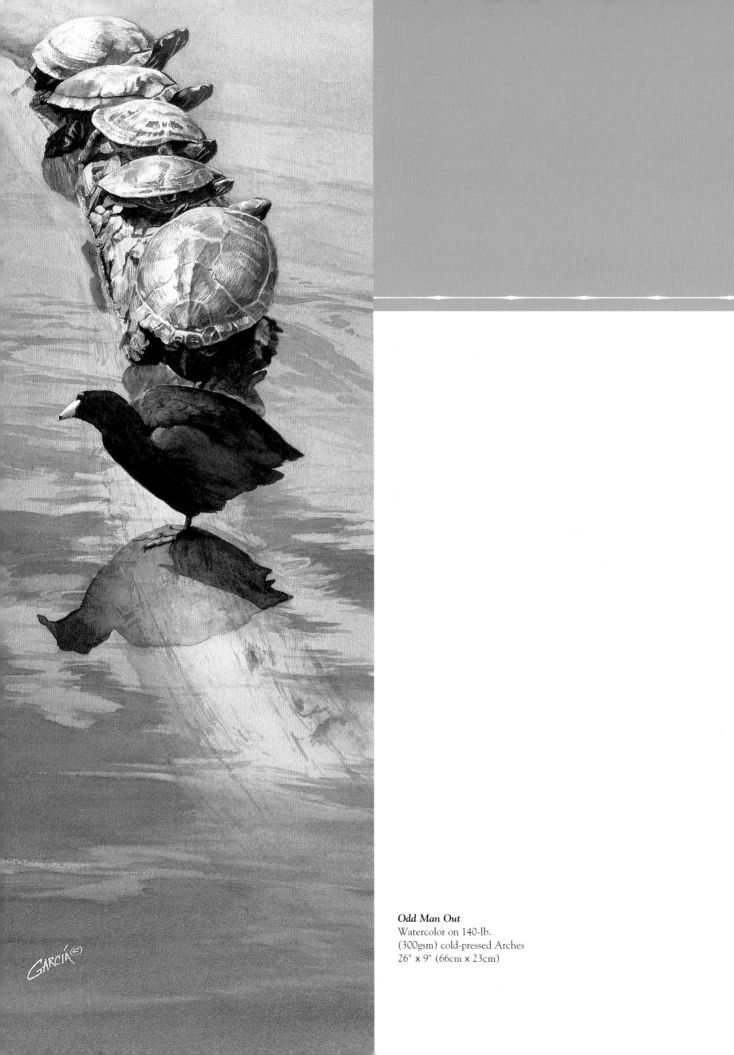

**Odd Man Out**
Watercolor on 140-lb.
(300gsm) cold-pressed Arches
26" x 9" (66cm x 23cm)

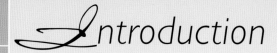

# Introduction

Painting with watercolors has always been magic to me. Painting a wet-into-wet wash and watching a sky appear is like pulling a rabbit out of a hat. I have heard that watercolor is the most difficult medium to use. I disagree. Anyone can learn to paint with watercolors; however, a person must be willing to start with the basics. That starting point is the wash. It is the foundation of watercolor painting. Learning to control the wash will open the door to the versatility and creativity of watercolors. This knowledge will allow you to tightly render or loosely interpret your subject.

In *Mastering the Watercolor Wash* I explain the basic wash techniques. Become familiar with brushes, paint and paper. Discover how much water to use and when to use it. Develop the habit of planning your painting. Think through the process of painting the most basic wash. If the subject you are about to paint is complicated, study and analyze how it will translate to watercolors. Look at the areas as large shapes. Decide how washes can be used. Do a pencil line or value study. Be prepared.

Use *Mastering the Watercolor Wash* to help you set goals, which will help you see progress and keep you motivated. Painting thirty washes using a variety of colors might be a beginning goal. A more advanced goal might be to paint one painting a week. A goal is like the carrot on the stick—always out there, but never quite within reach. Paint the subjects you like, so you will enjoy the progress and not become bored with it. I painted many subjects for this book that normally I would not have done. It gave me the opportunity to find new subjects and push my ideas in other directions. I hope this book gives you the motivation and desire to work with watercolors, and to learn and enjoy the ideas presented. I believe there are few people with true talent—talent, for most of us, is developed by effort, desire, tenacity and discipline. The magic is found when all your creative effort is joined together in a completed painting. Do you believe in magic?

### Using Strong Composition

I used a strong composition to develop a successful painting in *Yellow Wagtail*. I wanted to use many busy textures to complement the soft washes of the bird. I used flat washes on the rocks of the wall and a palette knife and dry-brush techniques for the textures. I incorporated wet-into-wet washes on the slate tiles. The moss on the top of the wall was painted first with a sponge and then with a brush to darken and define the shadows. The distant background was painted with a strong wet-into-wet wash. To create the dappled light effect, I scrubbed and lifted . The bird was painted with soft wet-into-wet washes. Strong lights and darks helped pull the painting together.

**Yellow Wagtail**
Watercolor on 140-lb.
(300gsm) cold-pressed Arches
12" x 33" (30cm x 84cm)

An important aspect of being a successful artist is being properly prepared. Preparation should start with a good attitude. The word "cannot" should be eliminated from your vocabulary. Be willing to make mistakes and learn from them. Being too critical of your work will dampen your enthusiasm and lessen creativity. Every brushstroke and every painting adds to your knowledge and experience. If painting was easy, what gratification would come from a successful painting? Few people are born with a natural talent, but each person has the ability to be successful. Talent is not as important as desire and effort. Work long and hard and this discipline will result in success. Do not be intimidated by

what you have not done, but be challenged by what you will do. Look at your best painting and say, "This is the best I can do today, but tomorrow I will do better." Learn the basic rules and set goals that will challenge you as an artist.

"Getting started" can hold many different meanings. A child learning to walk is not much different than a person using the brush for the first time. The child has the advantage of not being intimidated by failure. If you are not making mistakes then you are not painting. When I make a mistake I just don't tell anyone! The more you paint the easier it becomes, and you will complete successful paintings more often.

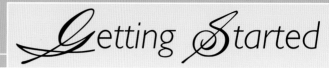

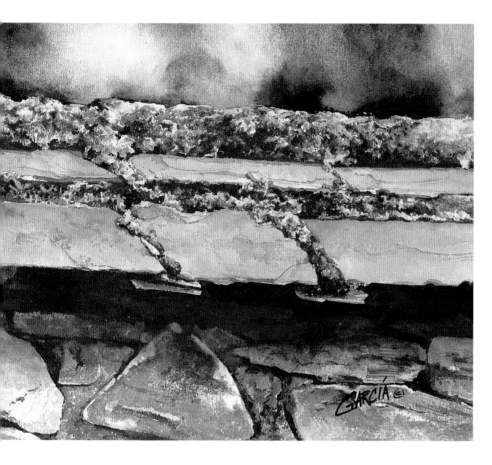

There are a few things that make getting started easier. I believe it is necessary to have an area set aside for painting. It can be a kitchen counter, table, television tray, drawing table or furnished art studio. The idea is to have a place that has good lighting and is comfortable. Although not necessary, it helps if materials can be left out day to day, making it more convenient to start each time. Good quality materials are also important. Three or four brushes with three or four tubes of paint are more than enough to start your painting career. Basic washes do not require more than one or two colors. A good wash is more significant than how many colors were used. Quality paper is

paramount. Inexpensive paper does not accept the pigment or brush-strokes as well as premium paper. The cost of a piece of paper can make the difference between a successful or unsuccessful painting. More people quit painting because they are discouraged than because they lack ability. Remember it is not how much you have, but how well you use it. Quality of materials does make a difference.

Sketch! This will help develop eye-hand coordination. Sketching will help you develop composition and see negative and positive shapes. Sketching will help you "see paintings." A camera is also a tool that should not be forgotten. Look through

the viewfinder. It can help you compose your paintings. The camera will record subjects that later can be painted. The video camera can be applicable as an aid in painting, too. The computer and scanner are also beginning to play a part.

Practice will always be the most valuable aid. Do not throw away paintings. Keep them tucked away. Every two or three months bring them out and you will see improvements. Remember that getting started is a never-ending process.

# Materials and Supplies

All watercolor artists tend to use the same materials. Personal experience will dictate individual differences in supplies. Beginning watercolor artists should be selective in what they purchase. Try not to buy more than is needed. A 1-inch (25mm) flat and nos. 4 and 8 rounds will start and finish almost any painting. Three or four tubes of paint, a couple of sheets of 22" x 30" (56cm x 76cm) professional-quality watercolor paper and you are ready to start. Purchase the three primary paint colors: red, yellow and blue, which will mix into a wide range of colors. A good book on color will explain warm and cool, color mixing, transparent and opaque, and color permanency.

Exchange ideas with fellow artists. Ask what equipment they use and why. What is their philosophy and approach to painting? This may influence what equipment you want to use. Becoming discouraged is less likely when you do not have to overcome poor-quality materials. My studio and traveling equipment are very similar, except in quantity.

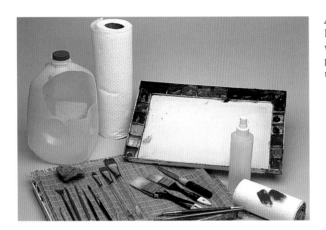

**Art Materials**
Brushes, palette, water container, paper towels or tissues.

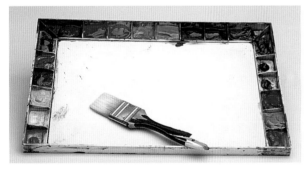

**Palette**
Any smooth, flat surface will make a good palette. I like to use the John Pike Palette shown here with a 1-inch (25mm) Langnickel flat.

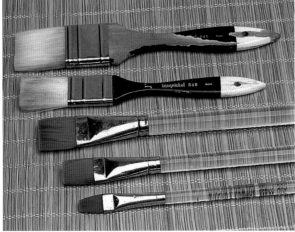

**Brushes—Flats**
Listed from bottom to top: Winsor & Newton Series 995, ½-inch, ¾-inch (19mm) (12mm), 1-inch (25mm); Langnickel Series 845, 1-inch (25mm), 1½-inch (38mm).

## Palette

Anything flat will work for a palette. A white dish, butcher's tray or cookie sheet will do the job, but a traditional covered palette is best. It will have separate wells or reservoirs to hold individual colors. This helps keep colors from becoming contaminated by adjacent colors when the palette is sealed, and the cover keeps the pigments moist. The John Pike or Robert E. Woods palettes are good examples. I personally use the Pike palette. Its heavy construction does not damage easily.

## Brushes

I like to use flats for washes and rounds for detail work. I can cover large areas quickly and with more control when using flats. Good brushes hold their shape and can carry a lot of wet pigment. I use both sable and synthetic

brushes. The synthetics work fine and cost much less. The brushes I use are: 1½-inch (38mm), 1-inch (25mm), ¾-inch (19mm) and ½-inch (12mm) flats. I use the 1-inch (25mm) and ¾-inch (19mm) flats, and nos. 2, 4, 6 and 8 rounds most often. There are many good manufacturers of brushes. Robert Simmons, Winsor & Newton and Grumbacher produce quality brushes. I use Kolinsky sables for my natural brushes. The Fritch scrub brushes work well for lifting, but oil bristle brushes serve the same purpose.

## Paper

There are numerous brands of paper available. Fabriano, Arches and Kilimanjaro are just a few of the choices. Paper comes in three textures: hot-pressed, which is very smooth; cold-pressed, which is lightly textured; and rough, which is heavily textured. Choice depends on style, subject and technique. Cold-pressed paper is good to start with. Paper also comes in various weights. I most often use 140-lb. (300gsm) or 300-lb. (640gsm) Arches. The weight or thickness is based on a ream, or five hundred sheets of paper. A standard-size sheet of watercolor paper in the United States is 32" x 40" (81cm x 102cm). As an example, five hundred sheets of cold-pressed medium-weight Arches paper will weigh 140 pounds (300gsm). It is strong, durable and can withstand my rough technique of painting.

Paper stretching should be mentioned. It is a process of soaking the paper and attaching it to your drawing board. Butcher's or brown paper tape, staples or clamps can be used for this purpose. The soaked paper expands, and as it dries, it will shrink back to its original size, leaving a very flat surface. I often paint very wet-into-wet and I have found that stretched paper will re-expand and wrinkle. Because of this problem, I now make my own watercolor board, which is described on page 14.

## Paints

Paints come in numerous brands. Start with the best. Use professional-quality paints and you will have fewer problems. I use Winsor & Newton, Holbein and DaVinci paints. How you arrange the colors on your palette is not as important as how you use them. When I first started painting I arranged them by convenience. The colors I used most often were across the top, and those used less frequently along the sides. Over the years, this has gradually changed—now I arrange the warm colors on the left, blues and greens (cool colors) across the top and earth colors on the right. Whatever palette arrangement you choose, stay with it. It saves time and prevents mixing the wrong paints. The colors I keep on my palette are: Permanent Red Medium, New Gamboge, Permanent Rose, Alizarin Crimson, French Ultramarine Blue, Cobalt Blue, Olive Green, Sap Green, Winsor Green, Burnt Sienna, Brown Madder, Sepia, Burnt Umber and Raw Sienna. I use tube colors and keep the reservoirs filled.

## Odds and Ends

I keep a lot of odds and ends available when I paint, things I might need for convenience or to create a texture. For example: pencils (2H, 3H, no. 2), a craft knife or single-edge razor blade, matches (used to heat the top of a tube of paint that is stuck tight), a palette knife and salt for texture, and Pelikan Graphic White. The list could go on with sponges, sandpaper, etc., but you get the idea. The important thing is to find what works for you. Paper towels or tissues, 3M painter's masking tape and a large water container are necessities. Some artists use two containers; one to wash the brush and one to rinse. Clean water and brushes are important.

**Lake Katherine, Hazelhurst, Wisconsin**
Watercolor in 80-lb. (170gsm) cold-pressed Liberte watercolor sketchbook
9" x 11" (23cm x 28cm)

# Making the Watercolor Board

I like to paint on a surface that will remain flat no matter how much water I use. At times I flood the paper with water. Even 300-lb. (640gsm) paper will get a slight buckle. My solution to this problem is to make my own watercolor board. It does not save time or money, but it allows me to use the exact surface I want. I also do not have to contend with any wrinkling or buckling. It is imperative to use acid-free or pH-neutral mounting board and glue. I like to make several boards of various sizes. When I do not feel like painting it gives me a project to do. I use scrap rag mat board left over from framing for the smaller sizes. For larger paintings I use a very heavy mounting board.

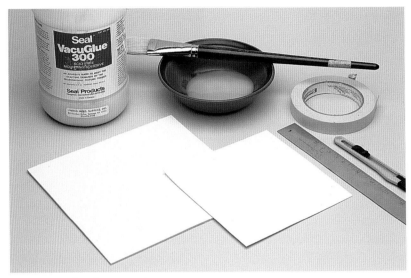

### Step 1 ~ Gather the Materials

Gather all the necessary equipment. You do not want to start and have to stop to look for something at a critical moment. Be prepared.

## Materials

Acid-free glue (Seal Vacuglue or Yes Glue work well)
Brayer or ink roller (optional)
Bricks or books for weights
Bristle brush for glue application
140-lb. (300gsm) cold-pressed Arches, any size
Pre-cut mounting board, 1" (3cm) larger than watercolor paper (Rag mat board scraps, Crescent 3XAF mounting board or Alpharag Artcare board by Bainbridge can be used for mounting)
3M painter's tape

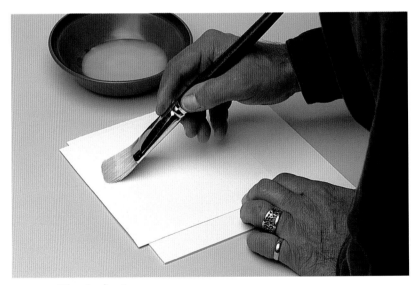

### Step 2 ~ Glue Application

Carefully brush a thin layer of glue on the back of the watercolor paper using the bristle brush. The mounting board should be a minimum of 1" (3cm) larger than the watercolor paper. Turn the glued surface over and center it on the mounting board. With your hand or brayer smooth out the paper. This will remove any air bubbles and flatten excess glue.

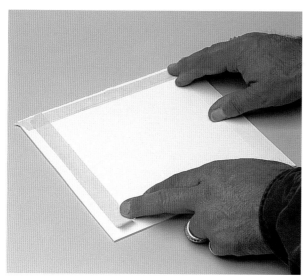

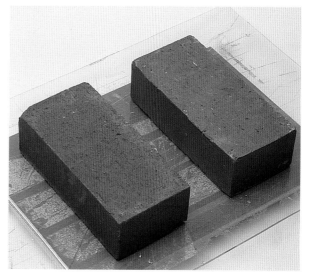

### Step 3 ~ Taping

Tape the paper to the mounting board. Use 3M painter's masking tape, which holds very well and resists water running under the edge of the tape. Tape about ¹⁄₁₆" (2mm) to ⅛" (3mm) into the paper to keep the paper from curling while the glue is drying.

### Step 4 ~ Weighting Boards Down

Prepare six to ten boards of the same size (you might want to prepare three or four different sizes). Make one or more stacks of the newly prepared boards and weight them down. Put a piece of old Plexiglas over the stack. Use bricks, books or something heavy to keep the boards flat. Small prepared boards can be used ten to fifteen minutes after gluing. Larger sizes should be left overnight to dry.

### Final

When the glue has dried remove the weights. The boards are now ready for painting. Leave the masking tape on until the painting is completed. When the tape is removed you will have a nice, clean white border, which allows space for the mat to be attached to the painting.

# Sketching on Location

The Jardins du Palais-Royal are found in the inner courtyard of the Ministry of Culture in Paris, France. On this crisp December day very few people strolled about enjoying the setting. A Frenchman had an entourage of dozens, if not a hundred, pigeons. A perfect painting! I used the pencil sketch to capture the moment. This helps me develop the idea and think about the composition. My first idea was a vertical format, as that is what I saw through the camera. After finishing the sketch I could see the possibility of a horizontal format. I used the placement of pigeons to move the eye across the composition. The use of color helped develop the idea. I eliminated some of the hungry little subjects and let the Frenchman be the focal point or center of interest. I may paint a similar painting in the future with more emphasis on the background.

I always have the sketches and photos for future reference.

I used transparent wet-into-wet washes to start the painting. Salt was used for the texture. Flat washes and directional brushstrokes helped develop movement across the ground. The colors in this area are Burnt Sienna, Raw Sienna and Cobalt Blue. The darker background has more Cobalt Blue added.

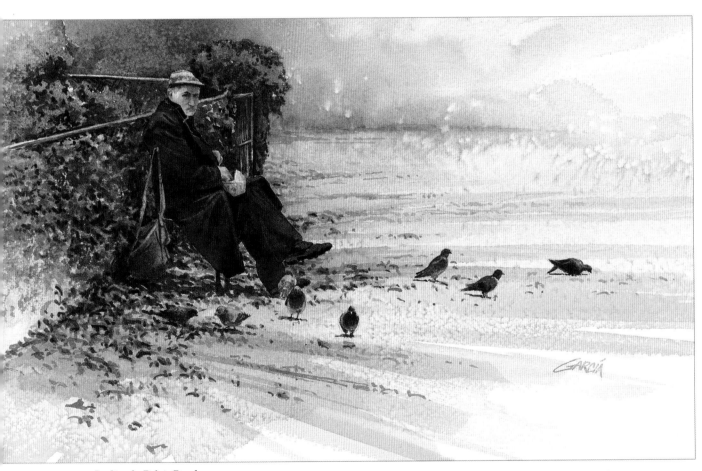

**Jardins du Palais-Royal**
Watercolor on 300-lb. (640gsm)
cold-pressed Kilimanjaro
9" x 14" (23cm x 36cm)

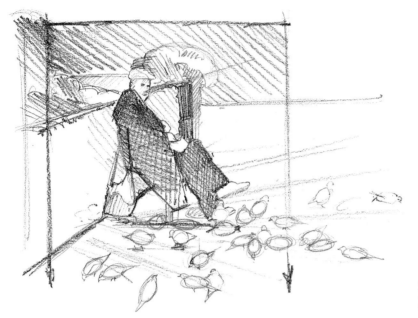

**Jardins du Palais-Royal Pencil Sketch**
Bond drawing pad
6" x 8" (15cm x 20cm)

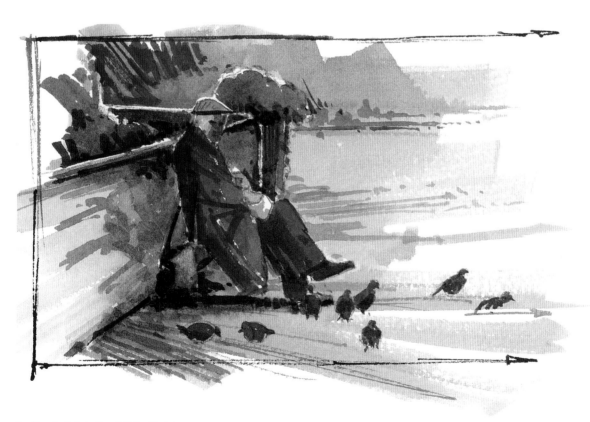

**Jardins du Palais-Royal Color Sketch**
Liberte watercolor sketchbook
5" x 8" (13cm x 20cm)

# Pen-and-Ink Washes

## Mini-Demonstration

Sketching does not always have to be thought of as the preliminary step to a painting. It can also be the final artwork. I prefer to sketch in permanent ink because I cannot erase or try to make corrections. I feel this gives the work a spontaneity and crispness that I lose with pencil. Plus, it does not smudge!

## Materials

*Paint*
    Alizarin Crimson
    Brown Madder
    Cobalt Blue
    French Ultramarine
      Blue
    New Gamboge
    Permanent Rose
    Sepia

*Brushes*
    Flats:
      1½-inch (38mm)
      1-inch (25mm)
      ¾-inch (19mm)
      ½-inch (12mm)
    Rounds:
      Nos. 2, 4, 6 and 8

*Other*
    180-lb. (385gsm) cold-
      pressed handmade
      Cyrano
    Drawing board
    HB to 2B pencil
    Masking tape
    Palette
    Palette knife
    Paper towels or tissues
    Pen and permanent ink
    Water

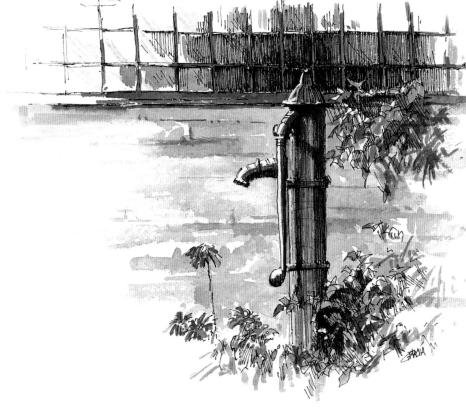

### Sketches Can Be Finished Works of Art

*Give Me a Hand* was sketched at a working farm, bed-and-breakfast in Killeagh, Ireland. The old pump was still functioning and used to water plants, chickens, cats and various animals wandering about. I started with pencil but switched to ink because the pencil did not have the dark values I wanted. All the washes are dry brush. The wall is painted with Raw Sienna, Burnt Sienna and Cobalt Blue. I used Alizarin Crimson to paint the pump. I consider this a finished piece of art that can be framed.

**Give Me a Hand**
Watercolor on handmade 180-lb.
(385gsm) cold-pressed Cyrano
9" x 7" (23cm x 18cm)

## Northern Oriole

*Northern Oriole* was started with a finished painting in mind. I know which washes I will use to get the appropriate textures.

### Step 1 ~ Complete an Ink Drawing

Start with a loose ink drawing. Use permanent ink that will not run when a wash is applied.

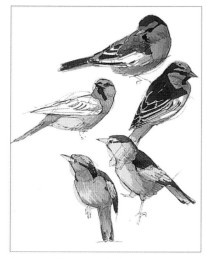

### Step 2 ~ Paint the Birds

Paint the yellow part of the bird with drybrush washes of New Gamboge and Permanent Rose. Paint the dark patterns with French Ultramarine Blue, Brown Madder and Sepia.

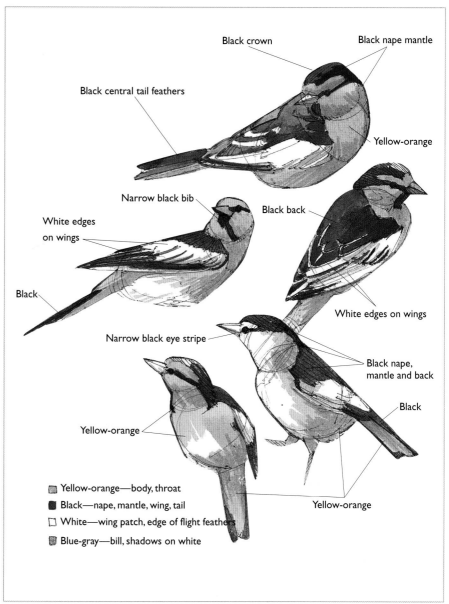

Black crown

Black nape mantle

Black central tail feathers

Yellow-orange

Narrow black bib

Black back

White edges on wings

Black

White edges on wings

Narrow black eye stripe

Black nape, mantle and back

Black

Yellow-orange

Yellow-orange

■ Yellow-orange—body, throat
■ Black—nape, mantle, wing, tail
□ White—wing patch, edge of flight feathers
▨ Blue-gray—bill, shadows on white

### Step 3 ~ Final

Add finishing details to the birds. Notice the contrast created by the rich dark black of the ink, the bright yellow and orange washes, and the white of the paper. By establishing the dark areas with the ink first I save time by not having to create many layers.

**Northern Oriole**
Watercolor on 180-lb. (385gsm)
cold-pressed handmade Cyrano
7" x 9" (18cm x 23cm)

# How to See Areas—Using Sketches and Ink Washes

An *area* is a flat surface or space. That definition does not explain how to see or paint that area. Also, a line drawing may not supply enough information to comfortably start a painting. Before you begin, paint some value studies. The use of values will help define the subject by looking at the light and dark areas. The use of line is kept to a minimum. Pencil or ink washes work well for this sketching technique.

With graphite I can soften areas with a cotton swab or a burnishing stump. Of the two choices, I like the ink washes best. They tend to be less messy and are similar to doing a small painting. All that is needed is a little ink or a tube of Sepia, a couple of brushes, a small plate and paper. Color is often intimidating and this is one way to break the ice.

*Autumn Marsh—the Migration* is a painting of the Blackwater Wildlife Refuge in Maryland. I used a quick pencil sketch to understand the tree and marsh area. Because of all the vegetation, the sketch helped me look at simplified areas. In the final painting I extended the area off to the left. I could use the sky to indicate the patterns of flying birds.

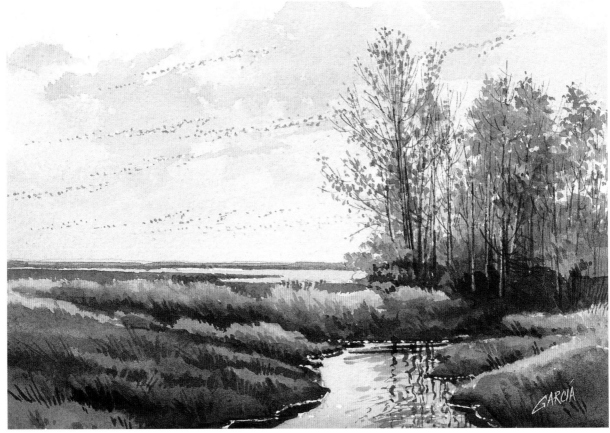

### Painting Marshlands
The marsh is started with a wet-into-wet wash of New Gamboge, Raw Sienna, Alizarin Crimson, Burnt Sienna and Cobalt Blue. I allowed these colors to run together. After this area dried, I used washes or glazes of the same colors to darken the values. The sky was painted using a gradated wash of Cobalt Blue. When this dried I gently drybrushed in the clouds. The trees and reflections were the last areas to be painted. The value studies were a great help. I had all the problems solved before I started!

**Autumn Marsh—the Migration**
Watercolor on 300-lb. (640gsm)
cold-pressed Kilimanjaro
6" x 9" (15cm x 23cm)

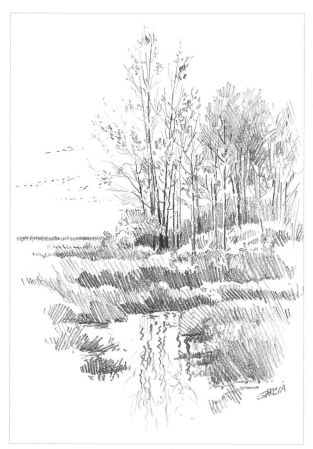

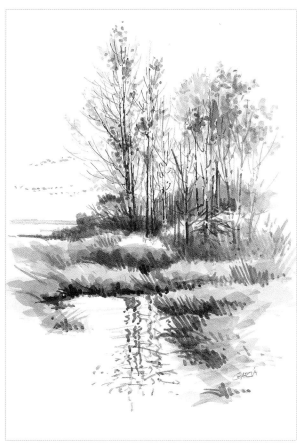

### Pencil Sketch

The pencil sketch of *Autumn Marsh—the Migration* was done using HB and 2B pencils. I sanded the points to get a chiseled edge. This helps fill in the area more quickly and has a nice textural quality. I used different values to indicate the separate areas of vegetation.

### Ink Wash

The ink-wash sketch of *Autumn Marsh—the Migration* is like doing a small black-and-white painting. What makes this fun is that you do not have to worry about color. If the values are correct, that painting will work. You can use washes to darken the values. These studies will often be more successful than the finished painting. Start with a very loose pencil sketch. Squint at what you are painting. This will help eliminate color so you see only shapes. Now start painting the light values and darken areas as you go along. Minimum equipment is required and maximum lessons can be learned.

# Defining Geometric Shapes

One way to define shapes is to think of them as geometrical forms—boxes, tubes or cones. All objects can be broken down into three-dimensional forms. This can be done to trees, mountains, figures, etc. I find this works well when I am painting buildings. A ready-made box! If this process seems complicated, a book on drawing will help. The book should explain vanishing points, horizon lines and line of sight. Just keep it simple. This method helps eliminate unnecessary detail and keeps things in perspective—no pun intended!

I found the roofs and chimneys of Paris to be intriguing. The various shapes, textures, colors and overlapping forms created endless possibilities to paint. Sketching helped isolate areas and see possible compositions. The camera viewfinder was also helpful in this process. The first step is to draw the boxes and tubes. Because of time limitation, weather or complexity of the subject, I may not proceed to the next step until I am in the comfort of my studio, where I can do a value study. In this sketch I can add more detail and develop the shadow structure of the painting. This stage can be black and white or the approximate colors to be used. The correct values are what I am looking for, not the color. These two steps made the transition to the final painting much easier.

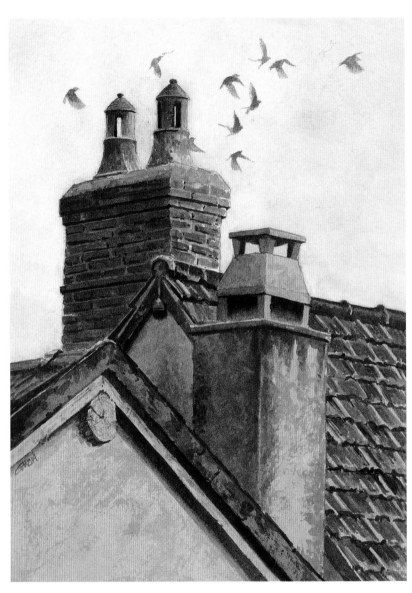

## Travel Inspires Art

The skyline of Paris offers many possibilities for paintings. The Eiffel Tower and other historic landmarks have captured the imagination of many artists. The chimney stacks and tiled roofs of Paris was the story I needed to put on paper— 300-lb. (640gsm) watercolor paper!

### Begin With the Correct Values
The final painting was started like the value sketch. Flat washes of Raw Sienna, Burnt Umber, Burnt Sienna and Cobalt Blue are used for the walls. The roof is Burnt Sienna and Cobalt Blue. One more flat wash of Cobalt Blue and Cerulean Blue is used for the sky.

**A Paris Skyline**
Watercolor on 300-lb. (640gsm)
cold-pressed Kilimanjaro
10" x 7" (25cm x 18cm)

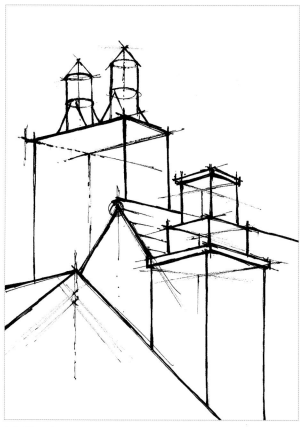

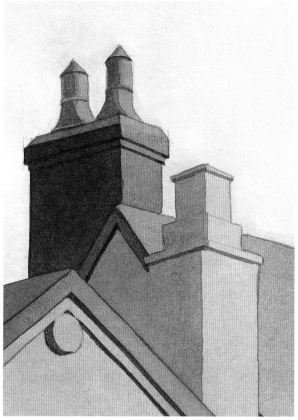

### Ink Sketch

A quick ink sketch helps me see how the subject has volume.
I get a feeling for the perspective and how the different shapes
relate to each other. This stage allows me to work on the com-
position and see if I like the negative shapes that have been
created.

### Value Sketch

A value sketch helps me see the relationship between the lights
and darks. The feeling of three-dimension becomes more appar-
ent and the negative shapes become more obvious. I now have
a firm grasp on what the final art will look like. Doing the final
painting is like adding frosting to the cake!

# Defining Organic Shapes

You can define organic shapes the same way you define geometric ones. Break the shapes down into three-dimensional forms. You may have to try a little harder to see the shapes but if you look, you can find them.

Along the coast, west of Kinsale, Ireland, the road ends at the water's edge. A small village, a rocky cove and a small sandy beach greet visitors. If there was a problem, it was only that there were too many venues to paint. A walking path left the cove and followed the edge of the cliffs for several kilometers. Each bend in the path beckoned me to see what visual inspiration lay beyond. Needless to say I could still be trekking the coast of Ireland if Anne had not put my palette knife to good use! She made sure I was turned around and heading back to the village. Not much painting was done, but the camera was put to good use. There are times one must be a tourist and enjoy the sights.

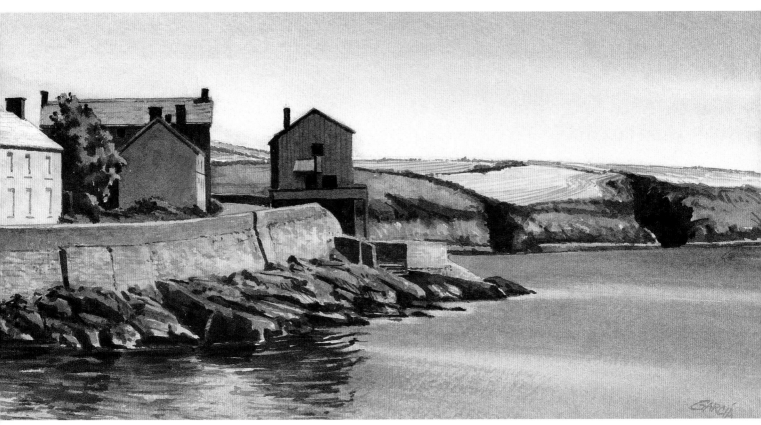

**West of Kinsale, Ireland**
Watercolor on 300-lb. (640gsm)
cold-pressed Kilimanjaro
6" x 13" (15cm x 33cm)

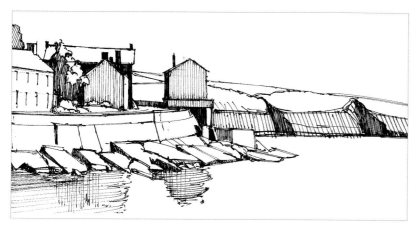

### Capture the Idea

Pencil or ink studies are a quick way to capture an idea. I prefer ink because the values are darker. If there are objects that need to be eliminated or moved, now is a good opportunity to do it. I look through the viewfinder of my camera to isolate areas. I then do a quick pencil sketch to find a composition. When I have settled on two or three ideas I can start preparation sketches for a final painting. I use this sketch to simplify areas. There were numerous cars, electrical poles and lines that needed to disappear. The joy of artistic license!

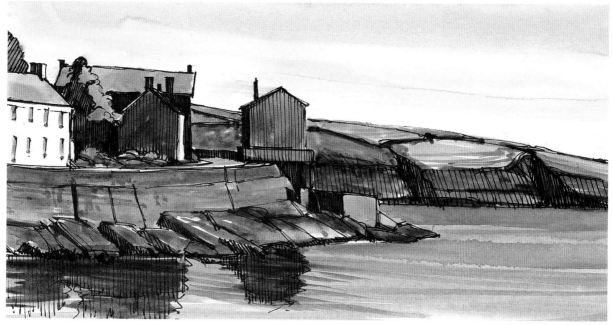

### Color Adds Information to Your Sketch

Color adds a little visual spice to a quick study. Watercolor blocks are convenient and work well for these location paintings. I like using Strathmore 400 bristol. It can be cut to any size and later bound or put into a notebook. The Micron Archival pens and watercolor work well on this paper.

# Editing—Using the Camera as a Tool

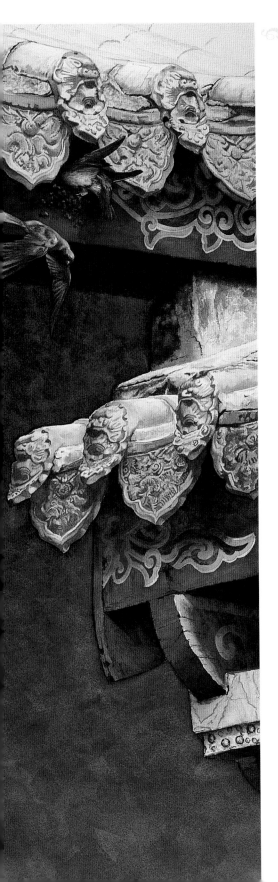

The camera is a creative tool. It records subjects I do not have time to sketch or paint at the moment. I use the zoom lens to crop and compose. When I look through the viewfinder I look for a painting. A landscape can be vast and overwhelming, but the camera can isolate areas. An empty 35mm slide holder acts much in the same way as the camera viewfinder. Hold the empty holder up to your eye and look through it. By varying the distance from the eye you can control how much is seen—a close-up or wide angle.

Take your own photographic references. Each person will *see* the same subject differently, just as they would *paint* the same subject differently. Prints or slides are a personal choice for reference. I like to use prints. I can lay them out on my table and look at them and find they are more easily filed. I often cut and tape them together. Slides, however, have better color and can be flipped to reverse the image. Slides also take up less room than prints. The digital camera offers many advantages. Once the images are transferred to the computer you can enlarge, crop, reverse or change the color of the image. The one drawback is that I have not figured out how to use the digital camera!

## Photographing the Lung-Shan Temple

The painting *Good Omen at Lung-Shan Temple* was possible because of the camera. I was invited, along with fifteen artists from various parts of the world, to participate in a six-week exhibit at the National Museum of History in Taipei, Taiwan. The artists were guests of the Taipei Ecoart Association. We were treated to a week-long trip to national parks and historic landmarks. Little time was available for painting, so the camera was an indispensable tool. I took photos of everything and anything. Whether it moved or didn't it was fair game! The last historic landmark I visited was the Lung-Shan, or Dragon Mountain, Temple. The 260-year anniversary of the temple was being celebrated and it was packed with people. It seemed as if every inch of the temple was covered with color, design or texture. I took countless photos. I had many paintings in mind but would have to wait until I returned home to compose paintings from the photos. *Good Omen at Lung-Shan Temple* was painted from one photograph. I used a little artistic license and removed a lantern, lowered the upper roof and added a swallow and nest. In Chinese legend it is a good omen when a swallow nests under the eave of your roof. I could not think of a more fitting conclusion to an incredible trip than to do my first painting from Taiwan of the Lung-Shan Temple.

**Good Omen at Lung-Shan Temple**
Watercolor on 300-lb.
(640gsm) cold-pressed Arches
32" x 10" (81cm x 25cm)

## Manipulating Photographs

This photo was one of approximately twelve hundred taken on my trip to Taiwan. Many were discarded and many more will never be used. It is always best to take too many photographs than not enough. Good photographic reference is irreplaceable. Years later I can go to my reference file, remove a photo and start a painting. Not only does it bring back memories, but I always have something to paint!

I use 200 or 400 ISO Kodak Gold film, and have it developed into 5" x 7" (13cm x 18cm) prints. When I get my photos back from processing I file them alphabetically by subject. The prints I expect to use first are put on a bulletin board to analyze. I will often cut and tape photographs together to get a pleasing composition. Do not get trapped into painting everything the photo shows. I use white artist's tape to mask out unnecessary areas in my photos. This allows me to isolate areas that I will use in the painting. If I change my mind or want to adjust the composition, I am able to remove and reposition the tape. The camera records only what you see, not what you paint. Change the image to fit the needs of your composition.

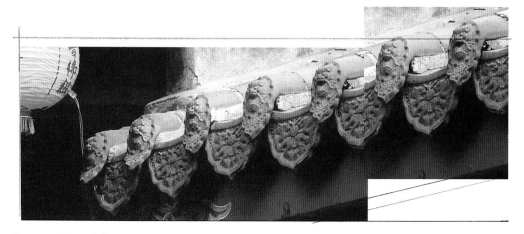

## Photography and Computers

Same photograph, but used a little differently. I decided that this image could also be a strong horizontal composition. I scanned the photo and then moved the last two tiles on the right up and over. With a little adjusting I am ready to start the painting. I must confess that Anne does all the computer work. I have not yet learned how to turn it on!

# Creating Interest

Developing confidence in your work will allow you to change or manipulate what or how you paint. As long as you follow the basic rules, your painting should be successful. Notice that I said *should*. Some of the basic rules are: 1) Have a plan before you start painting, 2) use good references, 3) paint light to dark and loose to tight, 4) use good composition and design, and 5) use a strong light source and shadows when appropriate. The most important rule to remember is: "Rules are made to be broken."

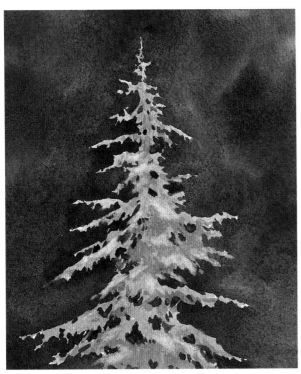

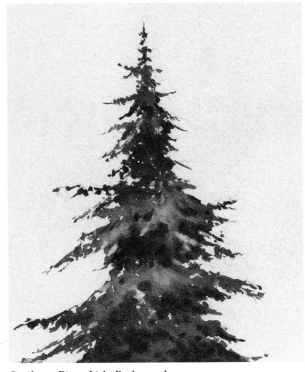

*Coniferous Pine—Light Background*
Watercolor on 140-lb.
(300gsm) cold-pressed Arches
5" x 4" (13cm x 10cm)

### The Relationship of Values—Contrast

These two coniferous pine trees demonstrate another rule. To see a light area or value, you must have a dark value behind it. The opposite is also true. This simple rule allows you to change the way you use a subject in a painting. You do not have to paint what your reference or subject shows. The dark background behind the light tree is a wet-into-wet wash. The light background behind the dark tree is a flat wash. Remember, it is the value that is important, not the color.

*Coniferous Pine—Dark Background*
Watercolor on 140-lb.
(300gsm) cold-pressed Arches
5" x 4" (13cm x 10cm)

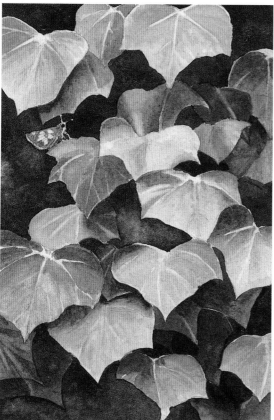

## A Different View

*Desert Shadows* was painted to show an alternative way of looking at a subject. I decided to tell the story by painting the shadows. Long cast shadows can add drama to a piece of art. In *Desert Shadows* the rules of dark against light and light to dark are used. The important concept is the use of shadows to describe the subject.

**Desert Shadows**
Watercolor on 140-lb.
(300gsm) cold-pressed Arches
4" x 6" (10cm x 15cm)

## Using Pattern or Repetition

*Mulberry Wing* uses the repetition of shapes or patterns to accent the center of interest. The large green ivy leaves create a pattern of similar shapes and colors. The warm light color makes the small butterfly stand out. Some artists will do the opposite and hide the subject in the patterns. This is called camouflaged art. Repetition of shapes can be tile on a roof or the pattern on a quilt. How you use this repetition of color or shapes can make your painting unique.

**Mulberry Wing**
Watercolor on 140-lb.
(300gsm) cold-pressed Arches
6" x 4" (15cm x 10cm)

# Using Negative and Positive Shapes

Good visual balance makes a successful painting. The elements of color, value, shape and texture must be arranged by the artist to convey an idea. The use of negative and positive shapes can enhance composition and design. Creating a strong design and composition reward you with a good painting.

   The center of interest is generally the positive shape. The negative areas are the shapes or spaces between and around the center of interest.

### Painting Complicated Negative Shapes

I used a lot of negative shapes to paint *Reeds*. First, I painted the reeds using a light flat wash of Burnt Sienna and Raw Sienna. Shadows and reflections were then painted. The shapes around and between the reeds are the negative areas. I used a wash of mixed Cobalt Blue and Alizarin Crimson to paint the water. I had to paint these areas twice. The first wash was not dark enough. The second gave me the opportunity to glaze over the reflections in the foreground. This was all done with flat washes. This darkening of value helped separate the reflections from the positive areas. The final step was to use a small scrub brush to lift highlights from the reeds. The point of a craft knife scraped across the paper created the sparkle on the water.

**Reeds**
Watercolor on 140-lb.
(300gsm) cold-pressed Arches
10" x 4" (25cm x 10cm)

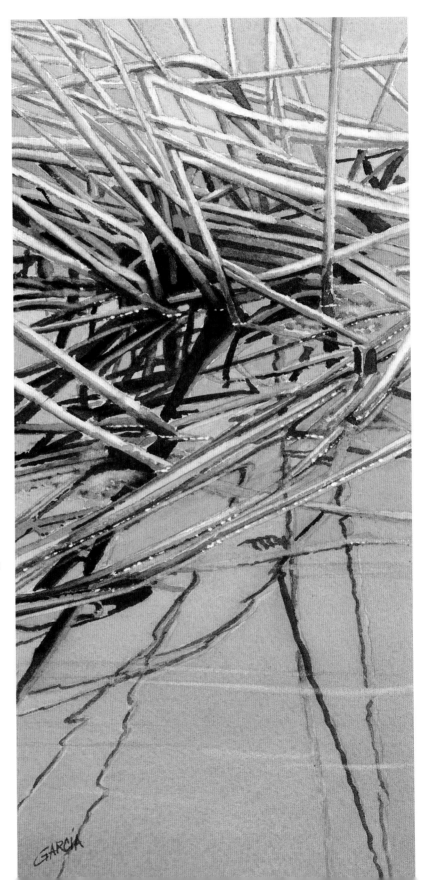

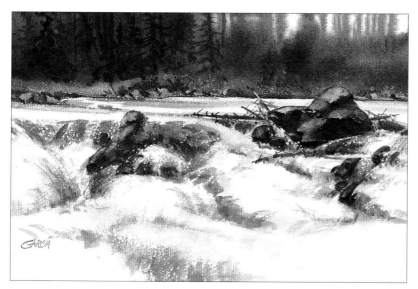

### Difficult Negative and Positive Shapes

*Rapids* is a painting where the negative and positive shapes are not as obvious. Think of the water as the positive shapes. The dark background and the shadows in the rapids are the negative areas. The background was painted using French Ultramarine Blue, Alizarin Crimson and Olive Green. The shadows in the water are French Ultramarine Blue and Alizarin Crimson. Sandpaper, craft knife and dry brush are used to get the texture of the water. This was a *rapid* application of texture—excuse the bad pun, but I had to say it!

**Rapids**
Watercolor on 140-lb.
(300gsm) cold-pressed Arches
5" x 8" (13cm x 20cm)

### Use Flat Washes to Define Negative Space

In *Daisy Delight* I used only flat washes. The flowers were painted first, using New Gamboge for the centers. The background area was painted with a series of flat brushstrokes. I let each layer dry before I glazed on the next series of brushstrokes. As I moved toward the center of the painting I darkened the value of the color. A wash of a Cobalt Blue, Winsor Green and Alizarin Crimson mixture was used in the negative area in the shape behind and around the flowers. Finally, I scrubbed out the color from the center of the flower.

**Daisy Delight**
Watercolor on 140-lb.
(300gsm) cold-pressed Arches
5" x 8" (13cm x 20cm)

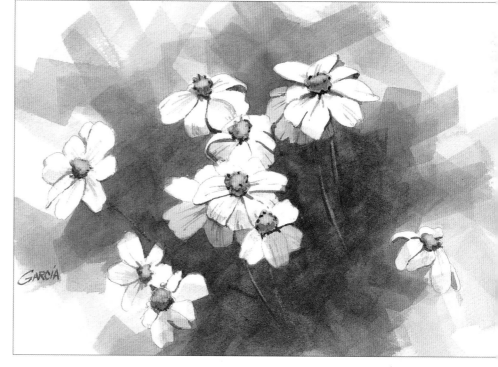

# Combining Elements to Create a Great Painting

*Wren's Roost* has everything in a painting that I like to use. Strong composition, light, textures and negative and positive shapes are all incorporated into this painting. This is another instance of studying an old abandoned building and trying to find a story to tell. The negative areas are the darks that surround the old corrugated metal.

These are painted as flat washes. The shadows on the wall and rain gutter contrast with the areas in light. Note the gradated wash used in these shadows. The reflected light at the end of the rain gutter was a very controlled wet-into-wet wash. The house wren was from a different location, but found its home in this painting.

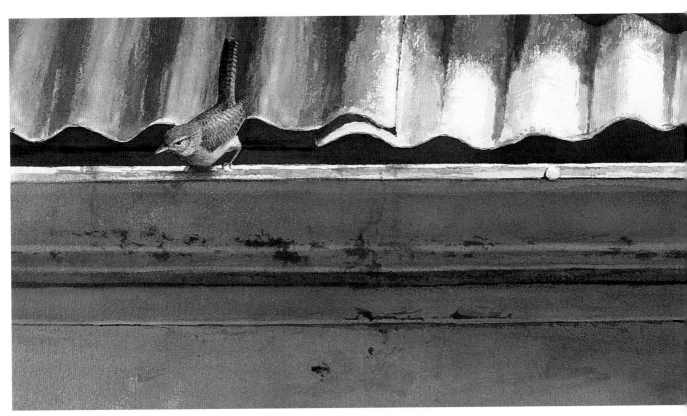

**Wren's Roost**
Watercolor on 140-lb.
(300gsm) cold-pressed Arches
13" x 32" (33cm x 81cm)

## Painting Clothes

When I am painting or taking reference photographs I am often dressed in old, worn clothes—painting clothes. Some people might call them rags! Once I was exploring an old abandoned house out in the countryside and I was wearing my painting clothes. I wasn't trespassing mind you, but gathering reference material. As I finished walking around, through and out of this old building, I was greeted by the local sheriff. He was wondering what vagrant was looking to move in! After I spent the next ten minutes of polite conversation describing the beauty of this old building he went on his way. I took a few more photos, and as I sat down to do a quick sketch, the local highway patrol officer pulled up! Need I say more?

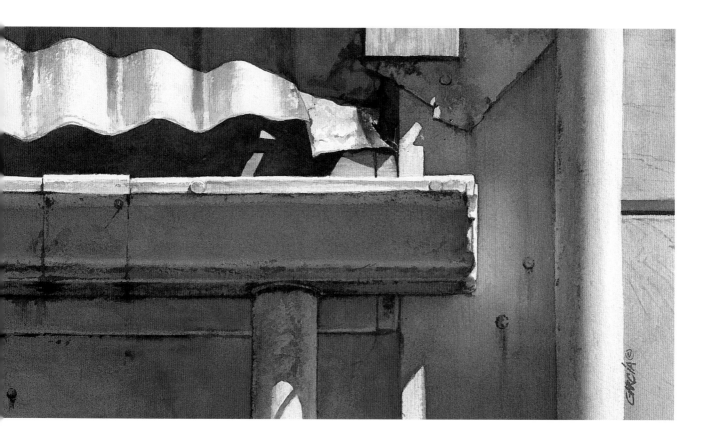

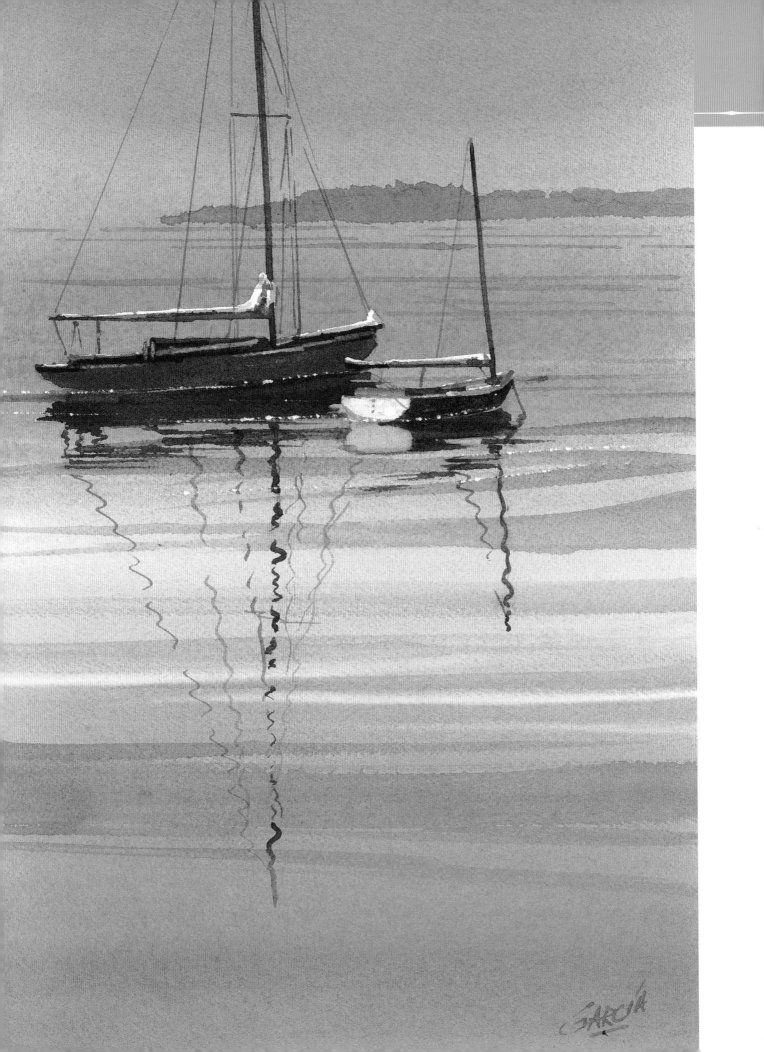

# Four Basic Wash Techniques

A strong foundation is needed to create a successful watercolor. Think about building a home. The foundation allows you to build whatever structure you desire. Composition, color, value and technique are the foundation's building blocks for your watercolor paintings. Practice is the labor that allows you to create your painting. What part does the wash have in this foundation? While it can play a part in composition, color, value and technique, technique will be its cornerstone.

Learning how to paint basic washes is relatively easy. The more you practice the easier it will become! With each wash you will learn brush control, color mixing and how to see color value. Don't worry about mistakes, trying is the important thing. I often call my paintings controlled accidents. I just don't tell my clients where the accidents are. Save your mistakes. They may prove to be the perfect texture for a future painting.

Washes will show you which colors granulate, stain or lift easily. You will learn how to mix colors on your palette or glaze with a wash on your paper. Remember, transparency and spontaneity are two of the basic beauties of watercolor. If the wash becomes shiny, you have lost its transparency. Spontaneity will come with practice and control.

As you sit down and prepare to start, be comfortable. Have your tools and brushes conveniently placed. Have a large water container filled and your palette with its colors ready. Remember the building and its foundation. Your approach to painting will dictate the style of your building—loose and casual, tight and formal, or anything in between. Learning the basic washes and how to use them will make all this possible. After twenty-five years of painting, when new colors and paper come out on the market, I still practice my washes.

**At Anchors**
Watercolor on 140-lb.
(300gsm) cold-pressed Arches
12" x 8" (30cm x 20cm)

# The Four Basic Washes

There are four basic washes I feel are important for you to know. Once you understand the process of how to do these washes, the world of watercolor painting opens up to you. These four washes are: flat, gradated, wet-into-wet and streaked. Painting each one requires a slightly different approach.

Remember that washes come in a variety of sizes, shapes and colors. A wash can cover the entire paper or the smallest of areas. There is no rule on how washes should be done. It is up to you, the artist, to make them work for you.

Remember also that practice is the key to success. I have spattered paint on the walls, puddled pigment on the

### Flat Wash
The flat wash looks like the name implies. There is no gradation from top to bottom or side to side. It has one value. This is a great wash for skies or buildings where a flat value is needed.

### Gradated Wash
This wash is one that gets progressively lighter in value. The gradated wash starts with the desired color and value and more water is added as the wash continues. It's a great wash for landscapes where mountains fade into the mist or dark rich skies fade into the horizon.

floor, and splashed color across my tabletop, all for the quest of the perfect wash!

I find the smaller the wash, the easier it is to control. My samples are 2" x 4" (5cm x 10cm) on 140-lb. (300gsm) cold-pressed Arches. The paper is mounted on acid-free board as previously discussed. This will prevent any buckling or warping of the surface. 300-lb. (640gsm) cold-pressed Arches will also work. Arches is the only paper I have found that will not tear when the tape is removed.

### Wet-Into-Wet

The wet-into-wet technique is the wash most often used. Colors are placed side by side on a wet surface and allowed to flow together. Soft blending is the result of this wash. Because of the wet surface there is less control. I find this is a great wash for my *controlled accidents*.

### Streaked Wash

The streaked wash is really a tool to get you to think about washes and texture. The color is placed on a wet surface, then you pick up your drawing board and tilt it in the direction you want the texture to run. I often use this technique when I want to show the wind blowing the clouds or rain.

# The Flat Wash

Flat washes can be used to create a distinctive style of painting. A lot of detail is eliminated and patterns of light and dark are constructed. When used as a glaze, especially as shadows, flat washes make a painting very dimensional.

The flat wash should have an even value. Try to keep the saturation consistent, whether it is 100 percent or 10. A very wet surface is the key. Pick up your board and let gravity take out the uneven areas. Flat washes can give your paintings a very graphic look— great to use when painting inanimate objects such as buildings.

## Tips for Creating Washes

~ Measure and tape off your paper.
~ Mix more paint than you expect to use.
~ Keep your wash wet, going from top to bottom or side to side as needed.
~ Clean the edge of your wash of excess paint with a paper towel or tissue. I like to clean the borders after every step of the wash.
~ Pick up your drawing board and tilt it up or down, side to side. This helps eliminate unwanted texture.
~ Carefully remove tape, pulling away from the wash.
~ Note what colors you used and at what concentration.

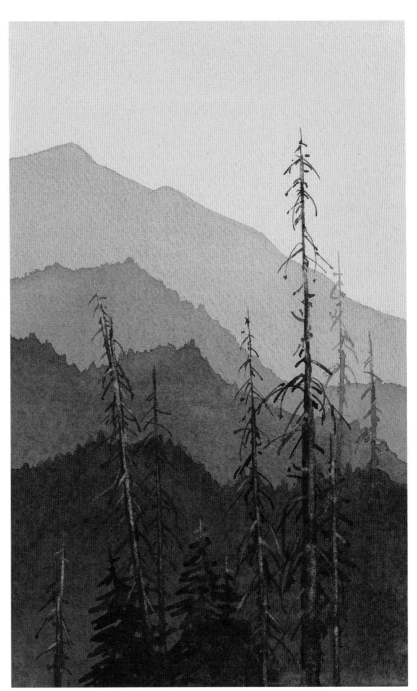

**Flat Wash as Background**
Use Raw Sienna with a little Permanent Rose for the background wash. As you paint into the foreground, add Permanent Rose and Cobalt Blue. Lift out highlights from the trees in the foreground.

*Evening Glow*
Watercolor on 140-lb. (300gsm) cold-pressed Arches
5" x 8" (13cm x 20cm)

# The Flat Wash

## Mini-Demonstration

The flat wash looks deceptively easy. I find the most important part of this wash is to mix a lot of paint on your palette—much more than you think you will need. Decide on what saturation the wash will be. Saturation is the amount of pigment in the wash. 100-percent saturation is the color or hue being used at its richest value and still remaining transparent. Anything greater than 100-percent saturation creates an opaque color or hue. You want to avoid oversaturation.

Draw a number of 3" x 6" (8cm x 15cm) rectangles on 140-lb. (300gsm) cold-pressed Arches. 300-lb. (640gsm) Arches is great but is slower to dry. Tape off the rectangles. The tape will act as a barrier to your wash.

### Step 1~ Load the Brush

Load the brush with paint. Start the wash with a rich wet brushstroke.

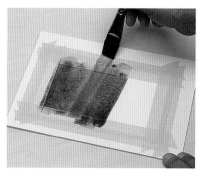

### Step 2 ~ Paint Down the Rectangle

Continue down the rectangle. Keep the strokes wet and loaded with paint. It's important!

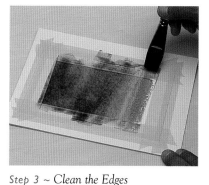

### Step 3 ~ Clean the Edges

Clean the edges of your wash if necessary. When you reach the bottom of the wash, make sure the covered area is still very wet. If you see any weak areas, repaint them.

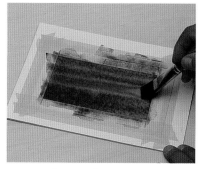

### Step 4 ~ Paint in the Opposite Direction

Load the brush with paint and apply the color in the opposite direction. Remember you still have to keep the transparency of the wash.

Pick up your board and tilt it back and forth and up and down. This will eliminate any unwanted texture and create a beautiful flat wash.

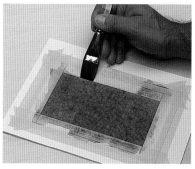

### Final

If a bead develops along the edge of your painting due to too much wash, use your brush to pick it up. Rinse your brush and squeeze the excess water out. Touch the damp brush to the bead and it will act as a sponge, pulling the moisture off the surface. Lay the wash flat and allow it to dry on its own. The use of a hair dryer is not recommended, as it will often push and puddle the wash.

## Materials

*Paint*
- Sap Green

*Brushes*
- Flats:
  - 1½-inch (38mm)
  - 1-inch (25mm)
  - ¾-inch (19mm)
  - ½-inch (12mm)
- Rounds:
  - Nos. 2, 4, 6 and 8

*Other*
- 140-lbs. (300gsm) cold-pressed Arches
- Drawing board
- HB to 2B pencil
- Masking tape
- Palette
- Paper towels or tissues
- Ruler
- Water

# Flat Wash

## Demonstration

I find subjects like buildings and landscapes are perfect for flat washes. This old barn was on a back country road near Mendocino, California. I did some sketches and took photos for a future painting.

## Materials

**Paints**
- French Ultramarine Blue
- Olive Green
- Permanent Rose
- Winsor Green

**Brushes**
- Flats:
  - 1½-inch (38mm)
  - 1-inch (25mm)
  - ¾-inch (19mm)
  - ½-inch (12mm)
- Rounds:
  - Nos. 2, 4, 6 and 8

**Other**
- 140-lb. (300gsm) cold-pressed Arches
- Drawing board
- HB to 2B pencil
- Masking tape
- Palette
- Paper towels or tissue
- Ruler
- Water

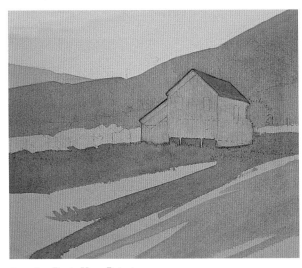

### Step 1 ~ Begin Your Painting

Start with a basic drawing, using the finished painting as a reference. Keep the drawing simple. Do not add much detail. Use a ½-inch (12mm) flat to wash in the color of the building. Do this as evenly as possible, and let dry completely. Start with your lightest background value and wash it in as evenly as possible top to bottom. I used a light Olive Green and worked quickly with a very wet brush. It is very important to let each wash dry thoroughly. If the underlying wash is not dry the color will begin to lift. As you move into the foreground, change the value or hue of each wash. I used some middle-value greens. Leave areas of the original background wash visible. It will help brighten and tie the painting together.

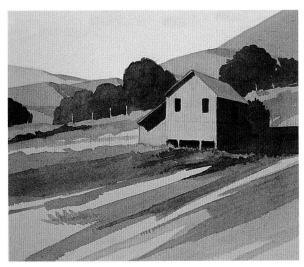

### Step 2 ~ Begin to Add Shadows

Complete all the flat washes in your painting. Use no detail, but wash or glaze all areas. Note the washes in the foreground. The shadows will add dimension or volume to your painting. Use a French Ultramarine Blue and Permanent Rose mixture for the shadow wash on the building and ground. Now do the shadows of the trees. Add a little Winsor Green to these shadows. Check your light source and keep the shadows on the same side as the building. Let everything dry completely.

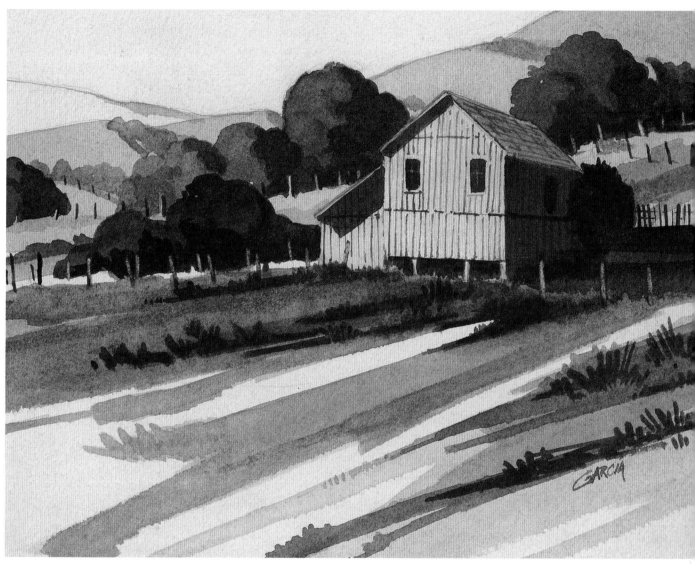

## Final

Finishing your painting is like adding frosting to the cake. Add the texture on the roof and face of the building. A no. 2 round will work well. Use the same brush to lift or scrub out some of the fence posts from the dark areas and add a few posts in the light areas. Now paint some of the grass texture in the foreground. Your painting is ready to be signed!

**Road to Mendocino**
Watercolor on 140-lb.
(300gsm) cold-pressed Arches
6" x 9" (15cm x 23cm)

## Unexpected Wash

I had a drawing on my desk and was getting ready to start the painting. As I turned to wet my brushes I knocked over my coffee. Because the contents spilled across the surface of my drawing, I had no choice but to take my largest flat brush and start my background wash. Two lessons were learned—I should keep my coffee off the table, and coffee is a great staining color!

## Tips for the Flat Wash

~ Start with a drawing that has little or no detail.
~ Use the largest brush possible.
~ Keep washes flat—start with lightest washes first, and remember not to blend.
~ When painting landscapes, work from the background forward.
~ Wash or glaze the shadows. Make sure the underlying washes are totally dry.
~ Finish with detail.
~ Add or lift color where needed.

# Advanced Flat Wash Studies

After you have practiced the basic flat washes try some more advanced subjects. Remember that flat washes will help organize your value patterns. They will help keep your paintings clean and not overworked. You will start looking at the total surface of the painting and how to incorporate the main subject. You won't get locked in to painting the main subject first. Flat washes are great for mood paintings, such as sunsets.

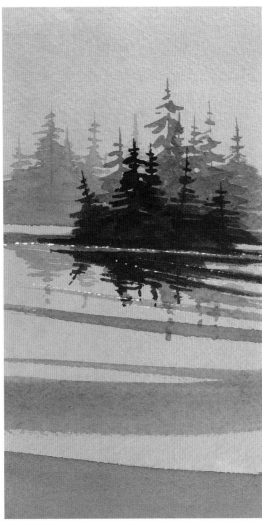

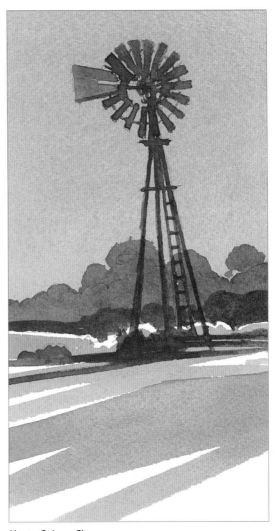

### Vary the Amount of Water to Change Values
Use Cobalt Blue and Permanent Rose for the background. Use less water to make the wash darker in value for the midground trees. Keep the tree wash flat with little detail. For the darkest trees add a little Winsor Green to your mixture. Vary bands of color on the water to create movement.

*Trees*
Watercolor on 140-lb.
(300gsm) cold-pressed Arches
3" x 6" (8cm x 15cm)

### Keep Colors Clean
Start your painting with the sky wash using a thinned or diluted Cobalt Blue and Olive Green. Use clean Olive Green in the midground and Burnt Sienna in the foreground. Mix French Ultramarine Blue and Alizarin Crimson for the darks. Make sure each step is dry before proceeding to the next wash.

*Windmill*
Watercolor on 140-lb.
(300gsm) cold-pressed Arches
3" x 6" (8cm x 15cm)

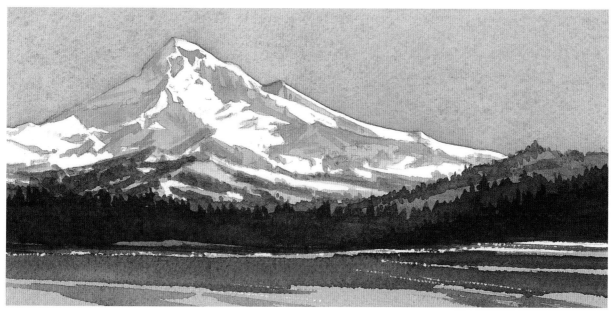

### Use Flat Washes for Shadows

Keep the washes flat—no blending. Use Cobalt Blue and Permanent Rose to paint the sky. The mountain shadows and the water are Cobalt Blue and Alizarin Crimson. The trees are a Cobalt Blue-Olive Green wash. Use Alizarin Crimson to darken the trees.

*Mount Hood*
Watercolor on 140-lb.
(300gsm) cold-pressed Arches
4" x 8" (10cm x 20cm)

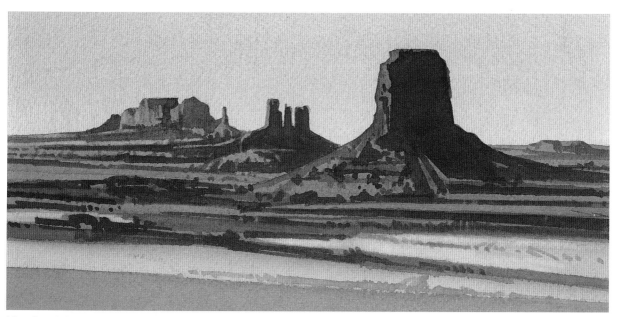

### Use Simple Washes

Start the painting with three flat washes. Use a Cobalt Blue-Permanent Rose wash for the sky. A Raw Sienna-New Gamboge mixture is used for the foreground. When these two washes are dry, paint the mesas over the sky wash. Use a Cobalt Blue-Alizarin Crimson wash for the mesas, increasing the values as they come forward.

*Monument Valley*
Watercolor on 140-lb.
(300gsm) cold-pressed Arches
4" x 8" (10cm x 20cm)

# The Gradated Wash

The gradated wash is one of the basic techniques of watercolor painting. Learning to control this wash opens the door to many successful watercolor paintings. I will show you how to start with a rich brushstroke of color and by diluting each successive brushstroke, create a beautiful gradated wash.

Start your first gradated wash on dry paper. Your first stroke should have the strongest color you want to use. Before each additional stroke, dip your brush into clean water. This will dilute the pigment in your brush. Continue this to the bottom of the paper. The last stroke should be clear water. If the wash does not have an even flow, start the process over before it dries. Picking up your painting and tilting it back and forth or side to side will help eliminate unwanted texture.

It is important to clean the edge of your wash with a paper towel or tissue. This will eliminate water or color bleeding back into your painting. Use your brush to pick up excess paint along the edge of your wash.

## The Biggest Wash

I was giving a demonstration for a large watercolor group and painting a wash for a background. I didn't realize as I was painting that I kept bumping my water bucket, moving it closer to the edge of the table. As I looked up, I managed to grab the bucket just before it went over the edge. I assumed all the "oohs" and "aahs" were for my great wash! I thought, as I caught my tipping bucket, that this could be the biggest wash yet!

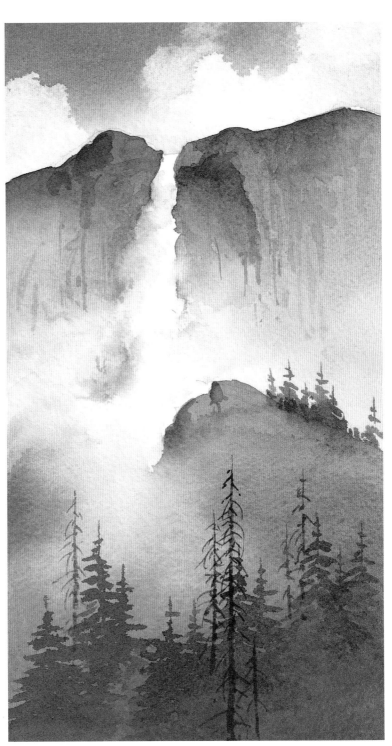

**The Falls**
Watercolor on 140-lb.
(300gsm) cold-pressed Arches
8" x 4" (20cm x 10cm)

# Gradated Wash

## Mini-Demonstration

The gradated wash should have a nice transition from dark to light. Start the wash on a dry surface. Then try it on a wet surface. I find I have better success with a wet background when the painting is larger. After you have learned to control this first wash, try a second color going the opposite direction. This wash becomes a glaze and creates wonderful color variations.

Draw a number of 3" x 6" (8cm x 15cm) rectangles on 140-lb. (300gsm) cold-pressed Arches. 300-lb. (640gsm) Arches is great but is slower to dry. Tape off the rectangles. The tape will act as a barrier to your wash. Now you are ready to practice, practice, practice.

## Materials

*Paint*
    Rose Madder

*Brushes*
    Flats:
        1½-inch (38mm)
        1-inch (25mm)
        ¾-inch (19mm)
        ½-inch (12mm)
    Rounds:
        Nos. 2, 4, 6 and 8

*Other*
    140-lb. (300gsm) cold-
        pressed Arches
    Drawing board
    HB to 2B pencil
    Masking tape
    Palette
    Palette knife
    Paper towels or tissues
    Ruler
    Water

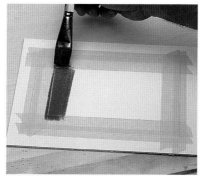

*Step 1 ~ Load the Brush*

Load your brush with color. This first brush-stroke will be the richest and strongest application of color.

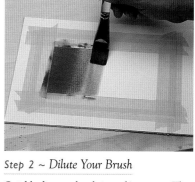

*Step 2 ~ Dilute Your Brush*

Quickly dip your brush into clean water. This will dilute your brushstroke.

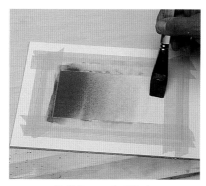

*Step 3 ~ Pull Down the Wash*

Continue to bring the wash to the bottom of the rectangle. With each stroke, dip your brush back into the water. When you reach the bottom of the wash, it should have little or no color.

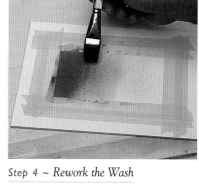

*Step 4 ~ Rework the Wash*

Look at the wash. Is the gradation gradual and even? If not, rework the wash by repeating the same strokes. Start at the bottom with clear water and work upward, adding more color as you go.

*Final*

This is really a continual step. Clean the edge of your painting by using a paper towel or tissue to soak up the excess water and color. If the paint of the wash beads up along the edge of the tape, use your brush to lift this excess color. Rinse and squeeze the extra moisture from your brush. This will soak up the bead of paint like a damp sponge.

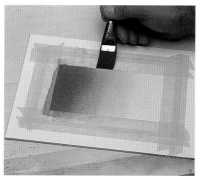

# Gradated Wash

## Demonstration

Gradated washes are a little more difficult to paint than the other washes, but once you have gained control over them, the world of watercolor begins to open up to you. As washes, they require more control and timing. You may start with dry or wet paper. In general, I find that starting with a dry background works more easily when the painting is small. The gradated wash is wonderful for still water, peaceful skies or mountain ranges moving into the foreground.

## Materials

*Paint*
- Alizarin Crimson
- Brown Madder
- Cobalt Blue
- French Ultramarine Blue
- New Gamboge
- Winsor Green

*Brushes*
- Flats:
  - 1½-inch (38mm)
  - 1-inch (25mm)
  - ¾-inch (19mm)
  - ½-inch (12mm)
- Rounds:
  - Nos. 2, 4, 6 and 8

*Other*
- 140-lb. (300gsm) cold-pressed Arches
- Craft knife or single-edge razor blade
- Drawing board
- HB to 2B pencil
- Masking tape
- Palette
- Palette knife
- Paper towels or tissues
- Ruler
- Water

### Step 1 ~ Time to Start

Use a mixture of French Ultramarine Blue, Cobalt Blue and Brown Madder on wet paper to create the background. The wet background dilutes the color, so start with more pigment in your first stroke. As you proceed after each horizontal stroke add more water to your brush.

### Step 2 ~ Your Second Wash

Start the second wash on dry paper using New Gamboge. Once again, with each stroke dip your brush into clean water. As you reach the middle of the paper, the wash should be clear. Pick up your painting and tilt it back and forth and side to side to smooth out any brushstrokes.

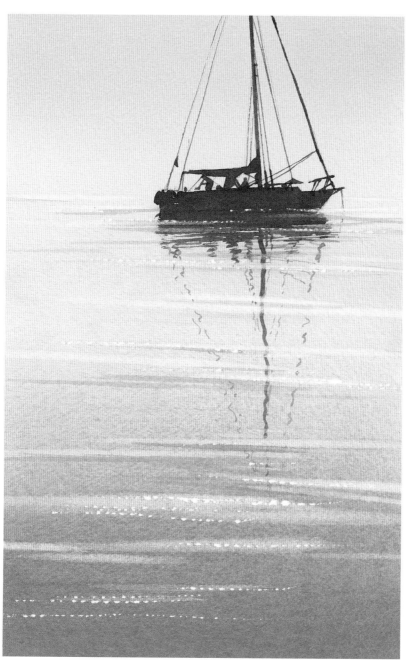

## Tips for the Gradated Wash

~ Smaller paintings are more easily controlled.

~ Decide if you will start with a dry or wet background.

~ A wet surface will dilute the wash so you will need to compensate for that.

~ Always use the largest brush possible.

~ Try to get the gradation as smooth as possible. Pick up your painting and tilt it up and down and side to side. This will help eliminate brushstrokes.

~ Paint the second wash with as few strokes as possible being careful not to reactivate the first wash.

~ Remember to clean the edges of the wash as you go along.

~ Practice, practice, practice.

**Still Waters**
Watercolor on 140-lb.
(300gsm) cold-pressed Arches
8" x 5" (20cm x 13cm)

### Final

The subject should be bold and strong in this painting. Use French Ultramarine Blue, Alizarin Crimson and Winsor Green for the dark silhouette. Add more color to brighten your subject. Next lift some of the water with a damp brush. The sparkle is achieved by scraping with the point of a craft knife or single-edge razor blade across the surface. Now stand back, and decide how you want to frame your painting.

# Advanced Gradated Wash Studies

Now things start to get more complicated. The basic gradated wash is still the same, but more care and control is required in its application. Remember, light and dark is controlled by how much water is in the wash. Now is the time to experiment. A little imperfection will only lend character to this wash technique.

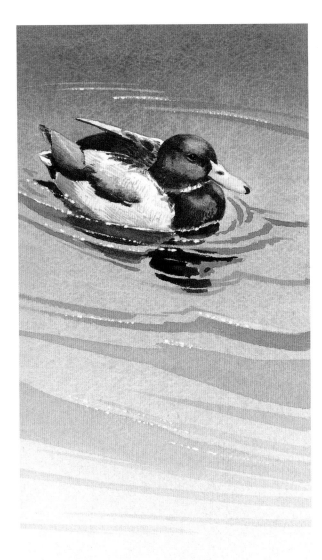

### Complex Subjects
This study is a little more complicated than it looks. The subject is painted first. A very wet-into-wet wash is used for the background using very saturated colors.

### Mallard
Watercolor on 140-lb. (300gsm) cold-pressed Arches
8" x 4" (20cm x 10cm)

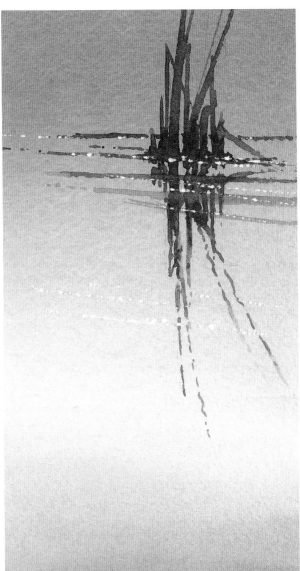

### Begin Your Wash on Dry Paper
The wash in this painting began on dry paper and ended with very little color at the bottom. After the first wash was dry, a second wash going the other direction was applied.

### Reflections
Watercolor on 140-lb. (300gsm) cold-pressed Arches
6" x 3" (15cm x 8cm)

**Sunrise**
Watercolor on 140-lb.
(300gsm) cold-pressed Arches
3" x 6" (8cm x 15cm)

### Gradated Wash on Wet Paper
*Sunrise* is the basic gradated wash but with a different approach. Wet your paper thoroughly and complete your first wash with a Cobalt Blue and Permanent Rose mixture. Now, starting in the other direction while your first wash is wet, do your second wash. Use a mixture of New Gamboge and Burnt Sienna for this wash. Now pick up your painting and let the two washes blend together. This blending is accomplished by tilting the wet painting back and forth and side to side. The mountains were done as dark-to-light washes using French Ultramarine Blue and Permanent Rose. Let each wash dry before starting the next.

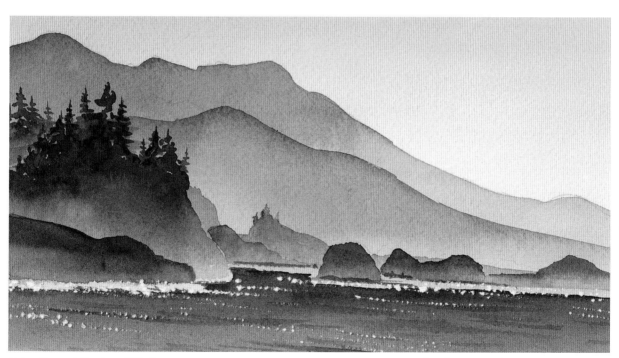

### Using Several Gradated Washes
*Coastline* is a series of gradated washes. First start with the sky using New Gamboge and Burnt Sienna. Use French Ultramarine Blue and Alizarin Crimson to do the mountains, but only paint part way to the bottom. Although the wash is gradated it is rapid in its transition. The small islands are dark-to-light washes. A round, pointed no. 4 was used to paint the trees and islands. The water is also a gradated wash from dark to middle-value.

**Coastline**
Watercolor on 140-lb.
(300gsm) cold-pressed Arches
8" x 4" (20cm x 10cm)

# Wet-into-Wet Wash

The wet-into-wet wash is the most versatile of washes in watercolor. This wash is what comes to mind when I think of loose, flowing, spontaneous watercolors. While flat, gradated and streaked washes all have specific characteristics, the wet-into-wet wash may incorporate all of these washes. For example, two gradated washes running into each other may be thought of as wet-into-wet.

The wet-into-wet wash should have a nice transition from one color to another. How gradual the transition will depend on the amount of moisture on the surface and if the wash is tilted back and forth and side to side. This is where spontaneity and creativity come into play. Experiment and see what you come up with.

## Painting in the Rain

I was painting on location in Sedona, Arizona. It was monsoon season but not raining in my area. The sky was spectacular. I was concentrating on my painting and did not notice a dark heavy cloud above me. Within seconds I was drenched. My painting was soaked and I had a wet-into-wet wash that wasn't planned!

### Complex Wet-Into-Wet Paintings
*Cactus Apples* is a very difficult painting. Each area is painted as a small wet-into-wet wash. Practice by painting one of the cactus apples first. They are painted with a mixture of Permanent Rose and Cobalt Blue at the top and a mixture of Olive Green and Aureolin Yellow below. Allow these colors to run together. The large cactus pad is a gradated wash. Use a wet-into-wet wash of the Olive Green-Aureolin Yellow mixture with a touch of Sap Green for the shadows.

Start the background on a dry surface. Add paint as you move around the subject. Add clean water and drag the color out to the border. Add a variety of colors to the background. The bottom of the painting is almost clear water. A difficult painting, but enjoyable to try!

**Cactus Apples**
Watercolor on 140-lb.
(300gsm) cold-pressed Arches
8" x 4" (20cm x 10cm)

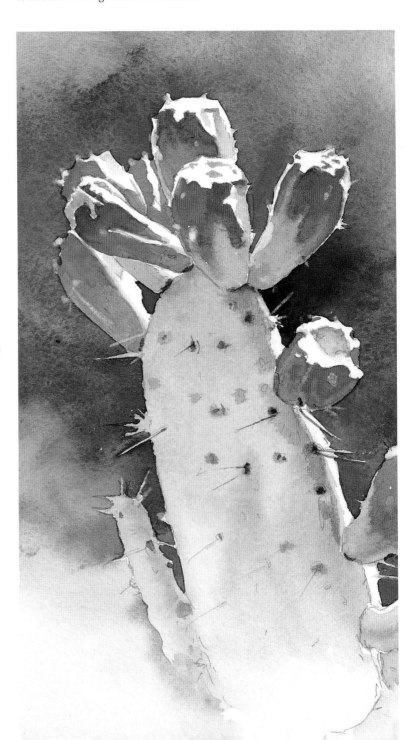

# Wet-Into-Wet Wash

## Mini-Demonstration

I generally start my wash with the paper totally saturated with water. I may cover the wash area two or three times to make sure it is totally soaked. I closely study the surface of the wet paper. If it is shiny I know it's very wet. If the surface is dull or soft looking it is beginning to dry. The amount of moisture on the surface will greatly influence how the wash works. A very wet surface causes the pigments to flow freely. A damp surface causes the pigments to gently blend. To accentuate the wash pick up the drawing board and tilt it back and forth and side to side.

Draw a number of 3" x 6" (8cm x 15cm) rectangles on 140-lb. (300gsm)

cold-pressed Arches. Tape off the rectangles. The tape will act as a barrier to your wash.

Keep the edges clean as you practice. Do some washes on a very wet surface and try some on a damp surface. Study the differences. Now imagine how these washes can be used in a painting.

## Materials

*Paint*
    Alizarin Crimson
    Cobalt Blue

*Brushes*
    Flats:
        1½-inch (38mm)
        1-inch (25mm)
        ¾-inch (19mm)
        ½-inch (12mm)
    Rounds:
        Nos. 2, 4, 6 and 8

*Other*
    140-lb. (300gsm) cold-
        pressed Arches
    Drawing board
    HB to 2B pencil
    Masking tape
    Palette
    Palette knife
    Paper towels or tissues
    Ruler
    Water

*Step 1 ~ Wet the Paper then Paint*

Wet the paper thoroughly. Clean the edges of excess water. Use Cobalt Blue for the first color. Apply the pigment but leave room for additional colors to be added. Check the surface of the paper. Is it very wet or damp? This will influence how the second color reacts in the wash.

*Step 2 ~ Add the Second Color*

Use Alizarin Crimson for the second color, adding it as soon as possible.

*Step 3 ~ Blend the Pigments*

The pigments will now start to flow together because of the wet surface. Pick up the drawing board and let gravity accentuate the flow or leave the board flat to let the wash dry on its own. Once you are satisfied with the wash allow it to dry thoroughly. Do not use a hair dryer. The force of the air will move the moisture on the surface. It will also not allow the surface to dry evenly.

*Final*

Clean the edges of the wash or painting. Excess moisture can run back into the painting, creating an unwanted texture.

# Wet-Into-Wet Wash

## Demonstration

Wet-into-wet washes are exciting to paint. You make decisions such as how wet you want the paper, how much pigment and water to load into the brush, and how much to allow the colors to run together. The textures, the blending of color and the spontaneity of wet-into-wet never lets watercolor painting become boring. I like to call these washes *controlled accidents*. I wait expectantly for the results, never sure exactly what is going to happen. Wet-into-wet washes are wonderful for sunset skies or misty forests. This wash can be used for subjects where the colors and textures gently blend together. This is your chance to loosen up and let the paper and color do the work for you!

## Materials

*Paint*
>Alizarin Crimson
>Aureolin Yellow
>Cobalt Blue
>Scarlet Lake

*Brushes*
>Flats:
>>1½-inch (38mm)
>>1-inch (25mm)
>>¾-inch (19mm)
>>½-inch (12mm)
>Rounds:
>>Nos. 2, 4, 6 and 8

*Other*
>140-lb. (300gsm) cold-
>>pressed Arches
>Drawing board
>HB to 2B pencil
>Masking tape
>Palette
>Palette knife
>Paper towels or tissues
>Water

*Step 1 ~ Soak the Paper and Apply Color*

Saturate the paper with clean water. You may need to brush water two or three times onto the paper to make it evenly soaked. This allows the wash to dry evenly. When the surface of the paper has a shine, apply the first brushstrokes of color. The shine means your paper is very wet and will allow your colors to run or flow freely. Use Aureolin Yellow and Scarlet Lake for the warm colors and Cobalt Blue for the cool colors. Pick up the drawing board and tilt it back and forth and side to side to help the blending.

*Step 2 ~ The Second Wash*

Mix the dark value of Cobalt Blue and Alizarin Crimson on your palette for the second wash. It is important to remember that the surface of the paper is damp and will dilute the pigment. Look closely at the paper. If it looks soft, it is beginning to dry and this dark second wash will not flow freely. At this stage timing and practice are important for success. If the paper is too wet the dark wash will float away; if it is too dry you will have hard-edged brushstrokes.

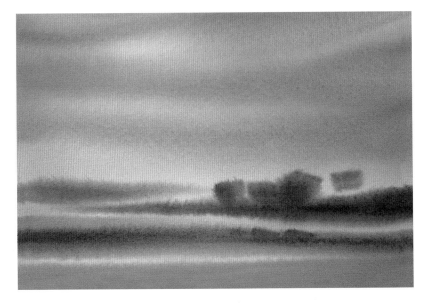

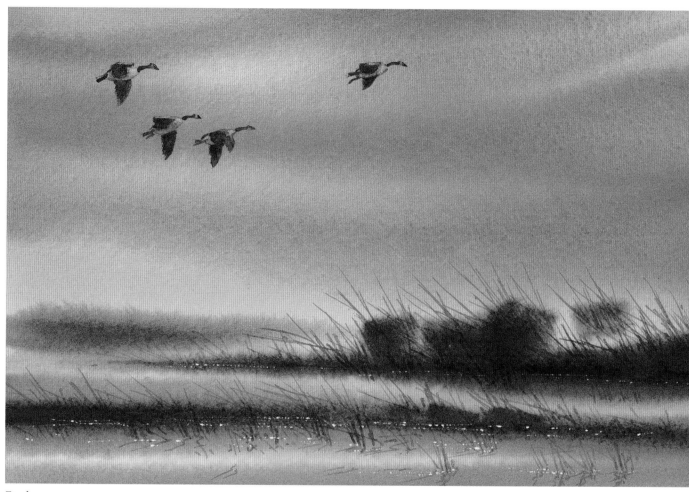

## Final

Look at your painting and critique what you have done to this point. The background should be very soft and have that wet-into-wet feel. The midground should be darker in value with a soft blending of color. This value change helps bring the dark area forward. Use a wash of Cobalt Blue and Alizarin Crimson for this dark area. Use the same color to paint the reeds and Canadian geese. Lift out a little color from the shoulder and chest of the birds by gently rubbing the area with a damp brush. Touch the area with a paper towel or tissue and the color will lift. Sign your finished painting. Place your signature in an area that does not disturb the composition of the painting.

**Evening Arrival**
Watercolor on 140-lb.
(300gsm) cold-pressed Arches
5" x 8" (13cm x 20cm)

## Tips for the Wet-Into-Wet Wash

~ When you start, the paper should be completely saturated with water.
~ Mix more color than you expect to use.
~ The wet surface will dilute the application of paint.
~ Tilt the drawing board to help the flow of paint.
~ As the paper begins to dry apply the next wash. The brushstrokes will be soft and more contained to an area.
~ Colors can be mixed either on your palette or on the paper.
~ It is important to clean the edges of the wash or painting to keep unwanted moisture from running back into the wash.

# Advanced Wet-Into-Wet Wash Studies

Try some quick, uncomplicated paintings. Keep the paintings small and easy to control. Start with a very wet background. This will help you get used to the amount of moisture on the surface of the paper. Remember, there are no mistakes, just *controlled accidents*!

These washes require a lot more control to be successful. If you need more drying time, try using 300-lb. (640gsm) cold-pressed Arches. Remember to eliminate detail and watch the dampness of the paper.

A wet-into-wet wash can cover an entire background or the shape of a leaf. Let the colors blend and mix on the paper. Go give it a try.

## Practice Your Timing

Start *Brush Line* with a wash of Cobalt Blue and Mauve on a very wet surface. Pick up the wash and tilt it upside down and side to side to help the colors blend. Check the dampness of the surface. When it has a soft look and is no longer shiny, add Burnt Sienna. For the shadows, wait a little longer and add a mixture of Cobalt Blue and Brown Madder. After the surface has dried use the same Cobalt Blue-Brown Madder mixture for the limbs. Do this painting many times until you get the timing of the second wash correct.

**Brush Line**
Watercolor on 140-lb.
(300gsm) cold-pressed Arches
3" x 6" (8cm x 15cm)

### Using Two Colors in the Background
Use Cobalt Blue, Brown Madder and Olive Green for this wash. Let the colors mix on the paper, not the palette. The more moisture on the surface the more the colors will blend. After the background dries, paint the trees using a mixture or French Ultramarine Blue, Alizarin Crimson and Winsor Green mixture. As the wash moves down, add Olive Green and New Gamboge. Let the colors blend.

**Forest Mist**
Watercolor on 140-lb.
(300gsm) cold-pressed Arches
3" x 6" (8cm x 15cm)

### Painting Detail

The bird of paradise is a wonderful flower to paint. It has lots of color and the petals create unusual areas. Do a light pencil drawing and think of the negative shapes of the background. Use Aureolin Yellow and Scarlet Lake for the orange hue. The colors used for the body of the flower are: Permanent Rose and Cobalt Blue for the purple area, Olive Green and Aureolin Yellow for the yellow-green area, and Alizarin Crimson for the red area. All these colors were painted wet-into-wet and allowed to run together.

The background is important; it helps frame the bright colors of the flower. Mix Alizarin Crimson, French Ultramarine Blue and Winsor Green into three separate puddles of paint. Wet the background of your painting with clear water. Start feeding the color from the puddles of paint into the background. Let the colors blend on the paper. Lift and tilt your painting to encourage the wet-into-wet effect. Paint the shadows on the flower to help define the individual shapes. A little lifting brings out the highlights.

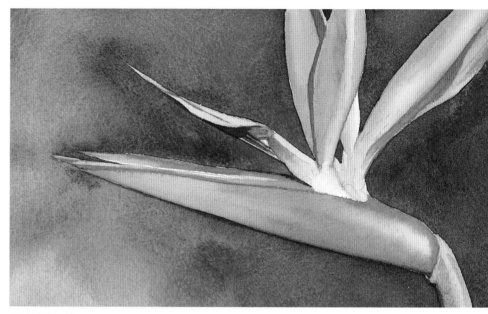

**Bird of Paradise**
Watercolor on 140-lb.
(300gsm) cold-pressed Arches
4" x 8" (10cm x 20cm)

### Perfect Timing

Timing is the success of *Sunrise Service*. The background wash is very wet-into-wet. First mix all the colors on your palette. Start with a wash of Cobalt Blue and Brown Madder. Below this, add a wash of New Gamboge and Scarlet Lake to the surface and let them blend. When the surface is slightly damp, use one or two brushstrokes to add a mixture of French Ultramarine Blue and Brown Madder to the bottom. Quickly rinse your brush and mix Cobalt Blue and Raw Sienna on the palette. Just before the sky wash dries, add the Cobalt Blue-Raw Sienna mixture to the cloud area. The background should dry as the newly added wash flows outward, leaving clouds with a golden lining. The trees and fence line are added as the last step.

**Sunrise Service**
Watercolor on 140-lb.
(300gsm) cold-pressed Arches
3" x 8" (8cm x 20cm)

# The Streaked Wash

Practicing a streaked wash teaches you control and timing. A streaked wash has a very definite direction of flow. This direction often becomes an important part of the composition of the painting. The flow or texture may be used to lead the viewer through the painting or to highlight or accent the main subject. The streaked wash may also be the underpainting for textures. This wash also could be called wet-into-wet or gradated depending on how it is applied to the surface of the paper. The texture created by the directional flow is what determines its name.

Learning to paint a streaked wash would seem quite easy. Just wet your paper, brush a few strokes of color on and let it run. If it was only that simple! Before you start your painting you must have a mental image of how you will use the wash. A small pencil sketch may help.

### Use Many Techniques When Painting

Try something a little different to paint *Lighthouse*. Draw the building and indicate where the rocks will be. Use clean water and paint to the edge and around the buildings. Saturate the area behind the buildings with water. Spatter water in the foreground. Paint the sky using Cobalt Blue, Viridian and Alizarin Crimson. As you paint the midground add Olive Green, Burnt Sienna and Mauve. Tilt the painting in both directions. Allow the color to run into the area of spattered water. Do the texture of the rocks just before the area dries. Use the edge of a palette knife like a squeegee. As you squeegee the paint away, use a paper towel or tissue to absorb the extra paint that builds up. If the area is too wet the moisture will run back into the scraped texture. Paint the building and you are finished!

**Lighthouse**
Watercolor on 140-lb.
(300gsm) cold-pressed Arches
4" x 7" (10cm x 18cm)

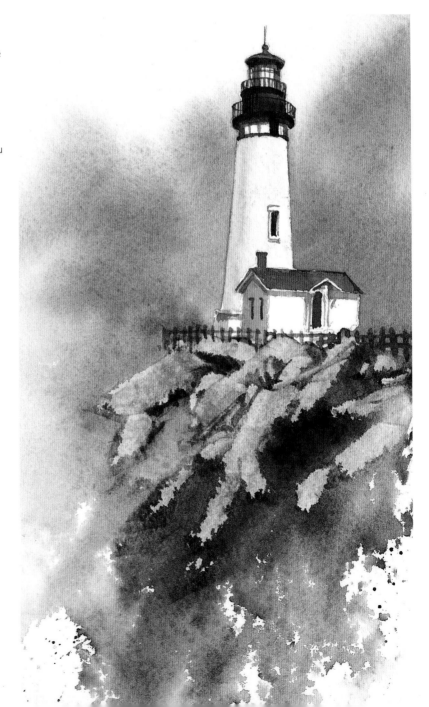

# Streaked Wash

🐚 Back to the prepared rectangles. The 3" x 6" (8cm x 15cm) area is easy to control, but you may use any size. Many artists are not comfortable painting small, even when practicing. Use 140-lb. (300gsm) cold-pressed Arches. The 300-lb. (640gsm) paper stays wet too long. Remember to keep the edges clean. An important distinction between this wash and a wet-into-wet wash is mixing the colors on the palette. With the wet-into-wet wash, the colors are mixed or allowed to run together on the paper.

Cover the wash area three or four times with clean water. This will assure complete saturation. Mix a wash of Olive Green paint on the palette. Practice the streaked wash to develop control and timing. Learning how to use the correct amount of moisture on the surface of the painting is essential to a successful watercolor painting.

*Step 1 ~ Apply Pigment to the Wet Paper*

Wet the surface of the paper using clean water. Use the largest brush possible to apply the color.

## Materials

*Paint*
>    Olive Green

*Brushes*
>    Flats:
>        1½-inch (38mm)
>        1-inch (25mm)
>        ¾-inch (19mm)
>        ½-inch (12mm)
>    Rounds:
>        Nos. 2, 4, 6 and 8

*Other*
>    140-lb. (300gsm) cold-
>        pressed Arches
>    Drawing board
>    HB to 2B pencil
>    Masking tape
>    Palette
>    Palette knife
>    Paper towels or tissues
>    Ruler
>    Spray bottle with a fine
>    mist (optional)
>    Water

*Step 2 ~ Tilt the Paper*

Pick up your drawing board and tilt it. Allow the wash to run in the desired direction. Soak up the excess paint and water on the outside edge of the wash. Set the wash on a flat surface and allow it to dry.

*Step 3 ~ Add More Color*

This is an optional step. If you would like to add an additional or a second color try this step. With a spray bottle that has a fine mist, evenly spray the painting. Check to see how much water is now on the surface. Add the additional color and tilt the painting again. This second wash should disappear into the initial wash.

*Final*

The streaked wash should have an obvious direction of flow. This wash can be used to develop composition and movement in a painting. As always, timing and control are essential in the success of this wash. Remember, practice makes perfect.

# Streaked Wash

The benefits of mastering a streaked wash are learning more than the control of wetness, paint saturation and drying time—you can begin to use the wash as part of the composition and design of the painting. The spontaneity and freshness is still there but an added dimension is brought into the picture. The streaked wash gives you one more tool to meet this challenge. Streaked washes are great for skies, rain, clouds and vignettes. Grab your brush, wet your paper, apply a couple of brushstrokes, and let's see what happens!

## Materials

*Paint*
- Brown Madder
- Cobalt Blue
- French Ultramarine Blue
- Viridian

*Brushes*
- Flats:
  - 1½-inch (38mm)
  - 1-inch (25mm)
  - ¾-inch (19mm)
  - ½-inch (12mm)
- Rounds:
  - Nos. 2, 4, 6 and 8

*Other*
- 140-lb. (300gsm) cold-pressed Arches
- Drawing board
- Masking fluid
- Masking tape
- Old synthetic brush
- Palette
- Paper towels or tissues
- Spray bottle with a fine mist
- Rubber cement pickup
- Ruler
- Water

### Step 1 ~ Prepare Your Wash

Sky and water are perfect subjects for this wash. Complete your drawing first. Use a masking fluid to save the white areas of the sail and boat. Allow the masking agent to dry thoroughly. Now soak the surface with clean water.

### Step 2 ~ Apply the Wash

When you are satisfied that the paper is saturated, add the wash. For this lesson mix large puddles of paint on the palette. Use Viridian and Cobalt Blue for the sky. Add French Ultramarine and Brown Madder to the puddle before you paint the wash behind the boat and sails. Check the surface of the painting for water content. If it is drying too quickly use the spray bottle to add moisture.

## Tips for Streaked Washes

~ Start with the paper completely saturated with water.

~ Study the surface to determine the amount of moisture on the paper. It should be fairly wet.

~ Use a large brush to apply your paint.

~ Tilt your painting to control the amount of flow. If the color runs too much, tilt it in the opposite direction.

~ Mask out complicated areas. Allow the masking fluid to completely dry. Remove the masking agent when the wash is completely dry.

~ Mix the color on the palette.

~ Add shadows and detail to the subject.

~ If an area is drying too quickly, mist it, using a spray bottle that has a very fine mist; tilt and let the wash run.

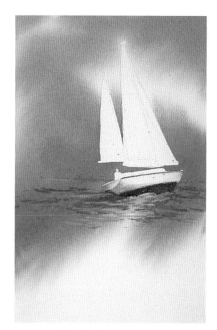

## Step 3 ~ Tilt the Paper

Pick up your painting and tilt it in the direction you want the wash to run. When you are satisfied with the wash, lay it flat and allow to dry completely. Now remove the masking agent using a rubber cement pickup.

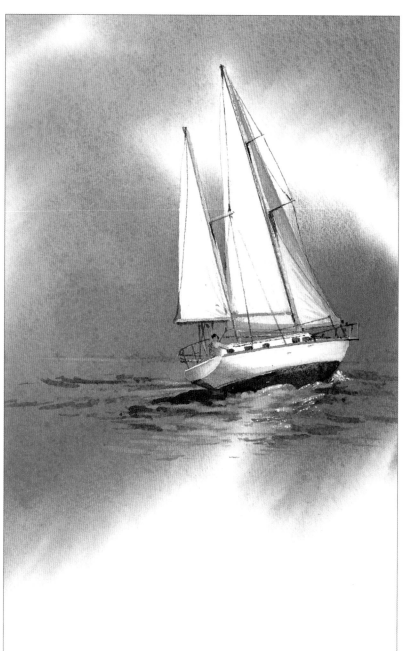

## Final

Add Brown Madder to the background color mixture to paint the shadows on the boat and sails. Lift out color on the water to indicate the horizon and swells. Add the small details to the subject and your painting is finished.

**Into the Wind**
Watercolor on 140-lb.
(300gsm) cold-pressed Arches
5" x 8" (13cm x 20cm)

# Advanced Streaked Wash Studies

You could also call this wash a graduated or wet-into-wet wash. The distinction is in controlling the direction of flow and texture of the wash. The colors are generally mixed on the palette and not on the paper. Remember to keep this wash clean and simple.

## Using the Streaked Wash

*White Face* is a wet-into-wet wash using the streaked wash technique. The calf was painted first. Use Burnt Sienna for the brown areas. Use Cobalt Blue and Permanent Rose for the shadows. Paint clean water up to the edge of the calf and over the rest of the background. While the background is very wet add Olive Green, Raw Sienna and Alizarin Crimson. Tilt the painting and let the colors run. On your palette make a mixture of the same colors, adding French Ultramarine. Use this mixture to spatter a texture. Practice first on scrap paper. Before the background dries, spatter clear water. Pick up the painting and allow the water to run back into the original wash. Rich strong color is important. Add as much detail to the background as you like.

**White Face**
Watercolor on 140-lb.
(300gsm) cold-pressed Arches
4" x 7" (10cm x 18cm)

## Mentally Plan Your Paintings

Start *Sea Gull* by carefully placing the bird and planning how the wash will be incorporated into the painting. Create a mental image of how you will do this. Start with a light pencil drawing of the subject. No masking agent is used. Paint the sky with a wash of Cobalt Blue, Cerulean Blue and a touch of Brown Madder. The colors are mixed on the palette. The sea gull is painted after the wash is dry. Highlights on the bird are lifted out of the background wash.

**Sea Gull**
Watercolor on 140-lb.
(300gsm) cold-pressed Arches
4" x 7" (10cm x 18cm)

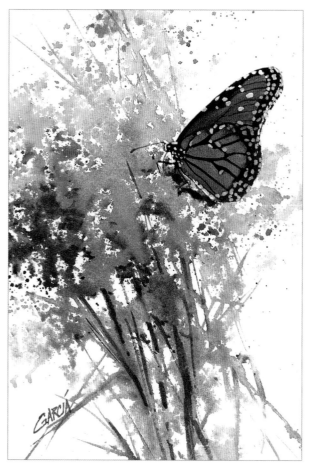

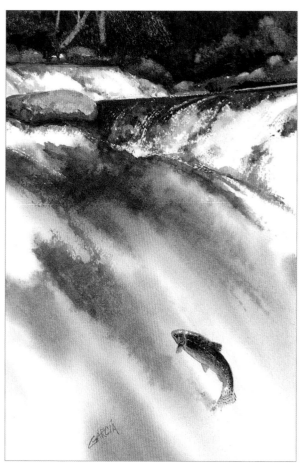

### Find Inspiration for Your Streaked Washes

My garden offers numerous subjects to paint; flowers, birds and insects. A light pencil drawing captured the butterfly. I then very loosely indicated the flowers. The white spots of the butterfly were masked out using a liquid frisket. When the frisket dried I painted the warm color of the wings using a Burnt Sienna wash darkened with Cobalt Blue and Brown Madder. The very dark areas are a mixture of French Ultramarine Blue and Sepia. When dry I removed the frisket. I used Cobalt Blue and Permanent Rose for a shadow color and carefully painted the whites. The background is a streaked wash. I splattered the background using clean water. I then splattered with color using Raw Sienna, New Gamboge, Burnt Sienna, Permanent Rose and Olive Green. I allowed the water to carry some of the color to the bottom of the painting to create stems and leaves. When dry I added shadows, leaves and the legs and antennae of the butterfly.

**The Monarch**
Watercolor on 140-lb. (300gsm) cold-pressed Arches
10" x 7" (25cm x 18cm)

### Experiment With the Streaked Wash

The use of the streaked wash in this painting is more obvious. Remember that a streaked wash is a wet-into-wet wash that is forced to run in an obvious direction. It is a texture and is used for a specific purpose in the painting. I painted the area of the falls with clean water. I made sure it was thoroughly saturated and would not dry too quickly. I then used a wet-into-wet wash of Cobalt Blue and Brown Madder. While this area was wet I picked up the painting and tilted it in the direction I wanted the paint to run. I used the background and rocks to help confine the water to a definite area. Raw Sienna, Burnt Sienna, Olive Green, Cobalt Blue and French Ultramarine Blue are used in these areas. Falling rain, running water, wispy, cirrus clouds are good subjects for using a streaked wash. Experiment, find some other subjects or use of the streaked wash.

**Going Up River**
Watercolor on 140-lb.
(300gsm) cold-pressed Arches
7" x 10" (18cm x 25cm)

# Combining Washes

Getting to know as much as possible about each wash is essential. I find each wash has its own personality. As I become more familiar with each wash I can decide more easily when, where, and how to use it. I also find that as with people, each wash can have many different moods. A wet-into-wet wash may be a dark, moody background. It could also be a soft, lyrical underpainting for a subject. As I explore various uses for washes I find a painting is rarely composed of one wash. It is generally a combination of washes, textures, good composition and values that create a successful painting.

Before I start to paint I try to see how one wash can complement another. A wet-into-wet foreground might contrast nicely with the flat washes of a building. I find there is no right way or wrong way to use a wash. The trick is to use the wash at the right time! How and why you use a wash is what makes a painting unique to you.

I find a small pencil sketch is helpful to see areas as shapes and values. It can help design and organize my painting. It also helps me visualize where certain washes can be used. I use the pencil sketch to develop good composition. A quick sketch often breaks the ice. If I am stumped on where or how to start the painting, a sketch gives me that starting point. My sketch can be anywhere from a quick line drawing to a well developed value study.

*Lonesome Dove*
Watercolor on 140-lb.
(300gsm) cold-pressed Arches
22" x 15" (56cm x 38cm)

# Wet-Into-Wet and Flat Washes

As I start my painting I like to take a minute or two and visualize how certain washes might be used. At times the technique is apparent or I might have a choice of washes to use. Often a quick pencil sketch helps develop my painting. I first look at the composition and then develop the values. It was easy to decide which washes to use for *Out on a Ledge*. The cat was soft and flowing, a perfect wet-into-wet wash. The window and bricks were well suited for a flat-wash technique.

The pencil sketch helped develop the composition. I think this painting would have been successful in a vertical or a horizontal format, but I felt the vertical gave more of a window effect. The pencil sketch helped me develop this idea.

Remember, your solutions should never be set in stone. The background could have been painted as a gradated, wet-into-wet wash or a combination of washes. Use techniques that suit your personality and work with the subject.

## Materials

*Paint*
- Brown Madder
- Cerulean Blue
- Cobalt Blue
- French Ultramarine Blue
- Permanent Red
- Permanent Rose
- Raw Sienna
- Sepia
- Winsor Blue

*Brushes*
- Flats:
    - 1½-inch (38mm)
    - 1-inch (25mm)
    - ¾-inch (19mm)
    - ½-inch (12mm)
- Rounds:
    - Nos. 2, 4, 6 and 8

*Other*
- 140-lb. (300gsm) cold-pressed Arches
- Drawing board
- HB to 2B pencil
- Masking tape
- Palette
- Palette knife
- Paper towels or tissues
- Ruler
- Water

*Step 1 ~ Sketch Your Image*

Do a quick pencil sketch to start the painting. An HB to 2B pencil will work nicely. This sketch will help organize your thoughts on the composition and values of the painting. The drawing will also help you decide what techniques you will use in the painting.

*Step 2 ~ Paint the Dark Values*

Use French Ultramarine Blue and Sepia for the dark areas of the cat. Wet these areas first with water. Now brush the dark mixture of paint into the damp areas. The color will flow out and soften. If an area is not dark enough try to add more color before it dries. The color used for the bricks is a wash of Permanent Red and Brown Madder. Apply this as a flat wash.

## Thumbs Up

When I paint outdoors I often do quick studies. People will notice my outstretched arm with my thumb lifted upward. As they get closer they will see me squinting. If they are artists they understand the process and what I am doing. Most people are curious as to why I am looking at my thumb with such a grimace! I explain that the thumb allows me to see size and scale. The squinting helps me to see shapes and values. Some walk away shaking their heads not understanding the process. Others look at their thumb a little differently.

### Step 3 ~ Shadows and Background

To paint the shadows of the cat, wet the areas to be painted with clean water. The shadow colors are a mixture of Winsor Blue, Permanent Rose and an initial wash of Raw Sienna. While the Raw Sienna wash is still wet, add the Winsor Blue-Permanent Rose mixture. Allow the colors to blend together as a soft wet-into-wet wash. As this wash dries and an area needs more value, add more of the shadow color. The underpainting for the glass and windowsill is a flat wash of Cobalt Blue and Cerulean Blue.

### Step 4 ~ Add Details

Make sure all the previous washes are dry. Now use a mixture of French Ultramarine Blue, Cobalt Blue and Brown Madder to paint the windowpanes. Mix a lot of color on your palette so you do not run out while applying this wash.

### Final

When all is dry add the shadows and texture. Your painting is now complete.

***Out on a Ledge***
Watercolor on 140-lb. (300gsm) cold-pressed Arches 8" x 5" (20cm x 13cm)

The pencil sketch of *Black-Eyed Susans* helped me decide how I wanted to do the painting. I decided to use a dark wet-into-wet background wash to highlight the bright flat wash of the flower petals. Painting is often a matter of using one theme against another to create contrast—light against dark, big against small, texture against texture. Colors can also be used with this concept in mind. The painting, *Black-Eyed Susans*, uses contrast and textures to create an image. The dark, loose wet-into-wet background helps bring out the flat bold colors of the flower. I also painted the dark center of each flower as a wet-into-wet wash. While the wash was still damp, salt was used to create the texture.

## Materials

*Paint*
- Alizarin Crimson
- Brown Madder
- Burnt Sienna
- Cadmium Yellow
- French Ultramarine Blue
- New Gamboge
- Sepia
- Winsor Green

*Brushes*
- Flats:
  - 1½-inch (38mm)
  - 1-inch (25mm)
  - ¾-inch (19mm)
  - ½-inch (12mm)
- Rounds:
  - Nos. 2, 4, 6 and 8

*Other*
- 140-lb. (300gsm) cold-pressed Arches
- Drawing board
- HB to 2B pencil
- Masking tape
- Palette
- Palette knife
- Paper towels or tissues
- Ruler
- Salt
- Water

### Step 1 ~ *Create a Pencil Sketch*

Draw a quick pencil sketch to capture the idea. Now is the time to play with the composition. Will this be a vertical or horizontal composition? Move the flowers around. Use the pencil sketch to help you decide on the value of the background.

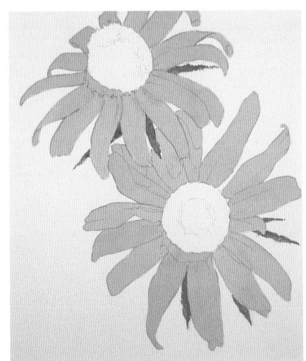

### Step 2 ~ *Apply the Flat Wash*

Paint all the petals with a flat wash of New Gamboge and Cadmium Yellow. Allow the petals to dry thoroughly.

## Step 3 ~ Develop the Painting

Now paint the center or flower head. Use a wash of Burnt Sienna, Brown Madder and French Ultramarine Blue. Add Sepia to this wash for the dark shadows of the flower head. Before this wet-into-wet wash dries, sprinkle a little salt on it for texture. Remember to brush the salt off when the wash dries.

## Final

Wash the background with clean water. Mix a wash of French Ultramarine Blue, Alizarin Crimson and Winsor Green. With a good pointed brush paint up to the edge of the petals with this wash. Do this part of the painting as a wet-into-wet wash. Vary the ratio of each color as you do this wash.

**Black-Eyed Susans**
Watercolor on 140-lb.
(300gsm) cold-pressed Arches
6" x 5" (15cm x 13cm)

# Flat and Gradated Washes

### Demonstration

*Cahir Castle, Ireland* shows the use of two washes—a flat wash for the castle, trees and shadows, and a gradated wash for the sky and foreground. Other washes could have been used but I felt these washes helped keep the painting easy to see. A busy background or foreground can conflict with the center of interest when a complex subject is being painted.

## Materials

*Paint*
> Brown Madder
> Burnt Sienna
> Cadmium Yellow
> Cobalt Blue
> French Ultramarine
>   Blue
> Olive Green
> Raw Sienna
> Sap Green

*Brushes*
> Flats:
>   1½-inch (38mm)
>   1-inch (25mm)
>   ¾-inch (19mm)
>   ½-inch (12mm)
> Rounds:
>   Nos. 2, 4, 6 and 8

*Other*
> 140-lb. (300gsm) cold-
>   pressed Arches
> Drawing board
> HB to 2B pencil
> Masking tape
> Palette
> Palette knife
> Paper towels or tissues
> Ruler
> Water

### Step 1 ~ Pencil Sketch

Use a pencil sketch to compose the painting. Do not show too much detail. The shadows are flat values and will define the structure of the building. The sketch will help you focus on what is important.

### Step 2 ~ Start With a Flat Wash

Start the painting with a flat wash for the castle, trees and midground foliage. Use a thin wash of Burnt Sienna, Raw Sienna and Cobalt Blue for the castle. The trees are a wash of Olive Green, Sap Green and Cobalt Blue. Paint the sky and foreground as gradated washes. The grass is a mixture of Olive Green and Sap Green, Cadmium Yellow and Cobalt Blue. Saturate the foreground area with water. Now do the wash from dark to light. The sky is a wash of Cobalt Blue and Brown Madder. Mix all the colors on the palette.

### Step 3 ~ Add Shadows

Now add the shadows to your painting.
There is very little detail. The flat washes
show the planes of the building and shapes of
the trees. The flat washes or shadows in the
foreground help bring the viewer's eye up to
the castle. The shadows on the castle are a
Burnt Sienna, Brown Madder and Cobalt
Blue wash.

### Final

Finish with the shadows on the grass and
trees using a flat wash of French Ultramarine
Blue, Sap Green and Brown Madder.

**Cahir Castle, Ireland**
Watercolor on 140-lb.
(300gsm) cold-pressed Arches
11" x 6" (28cm x 15cm)

# Flat, Gradated and Streaked Washes

*Badlands* uses a variety of washes. Before I start painting I like to study the subject and develop a mental image of how I will proceed. I started *Badlands* with a line drawing. This sets the composition and helps me see where the washes will be used. If I am not sure of the color or value of the wash I will test the color first. If I find the color I have mixed is not what I want, I will clean my palette and start over. It is better to mix a new wash than start off on the wrong foot!

## Materials

*Paint*
> Brown Madder
> Burnt Sienna
> Cerulean Blue
> Cobalt Blue
> French Ultramarine
> Blue

*Brushes*
> Flats:
>> 1½-inch (38mm)
>> 1-inch (25mm)
>> ¾-inch (19mm)
>> ½-inch (12mm)
> Rounds:
>> Nos. 2, 4, 6 and 8

*Other*
> 140-lb. (300gsm) cold-
> pressed Arches
> Drawing board
> H to 2H pencil
> Masking tape
> Palette
> Palette knife
> Paper towels or tissues
> Ruler
> Water

*Step 1 ~ Complete a Sketch*

Do a pencil drawing to develop the composition. Indicate shadows if desired, but it is not necessary. A few lines in the foreground will help move your eye up to the center of interest. Use an H to 2H pencil to draw on your watercolor paper. Do not press too firmly or it will score the surface of the paper. Now look at your drawing and decide how and what wash will be used.

*Step 2 ~ Apply the First Wash*

Use a flat wash of Cerulean Blue and Cobalt Blue for the sky. The streaked wash in the sky can be done one of two ways: 1) While the flat wash is still wet add a mixture of French Ultramarine Blue and Brown Madder. Tilt the painting and let the color run. 2) Let the flat wash dry thoroughly. Rewet the area and add the dark wash. Tilt the painting and let the pigment run over the flat wash. The mountain is a gradated wash using a Burnt Sienna, Brown Madder, and Cobalt Blue mixture.

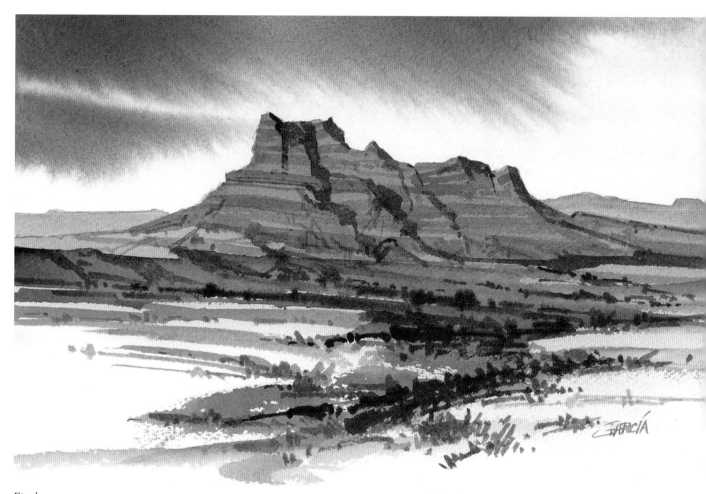

*Final*

After this wash is dry add the mountain and foreground textures.

**Badlands**
Watercolor on 140-lb.
(300gsm) cold-pressed Arches
5" x 8" (13cm x 20cm)

# Gradated Washes

## Demonstration

I like to keep paintings like *Alpine Lake* clean and simple. When painting outdoors I can become overwhelmed by the complexity of the subject. The first step is to simplify. I like to focus on an area and then decide what washes to use. My most successful paintings are ones that tell a story and are easy to read.

## Materials

*Paint*
  Alizarin Crimson
  Burnt Sienna
  French Ultramarine
    Blue
  Olive Green
  Permanent Rose
  Raw Sienna
  Sap Green
  Winsor Green

*Brushes*
  Flats:
    1½-inch (38mm)
    1-inch (25mm)
    ¾-inch (19mm)
    ½-inch (12mm)
  Rounds:
    Nos. 2, 4, 6 and 8

*Other*
  140-lb. (300gsm) cold-
    pressed Arches
  Craft knife or single-
    edge razor
  Drawing board
  HB to 2B pencil
  Masking tape
  Palette
  Palette knife
  Paper towels or tissues
  Ruler
  Water

### Step 1 ~ Sketch and the First Wash

Start by saturating your paper with clean water. For the first gradated wash use Raw Sienna and Permanent Rose. Paint from dark to light. Before this wash dries use a French Ultramarine Blue and Permanent Rose mixture to paint a gradated wash in the opposite direction. Keep the painting flat and allow it to dry. The pencil sketch can be done before or after these washes.

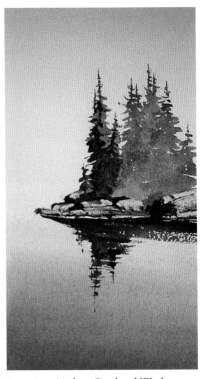

### Step 2 ~ Apply a Gradated Wash

Paint the trees and rocks as a gradated wash. Use French Ultramarine Blue and Olive Green for the trees. To paint the rocks use a wash of Burnt Sienna, French Ultramarine Blue and Sap Green. Before the rocks dry use the palette knife to squeegee out the highlights. As you squeegee the paint away, use a paper towel or tissue to absorb the extra paint that builds up.

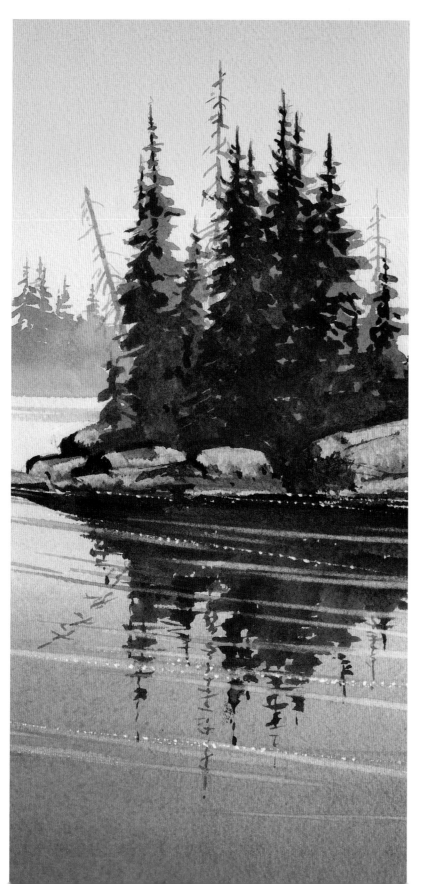

## Final

The shadows are a dark rich wash of French Ultramarine Blue, Alizarin Crimson and Winsor Green. Also use this color for the reflections in the water. Use the 1-inch (25mm) flat to lift the ripples out of the water. With a craft knife or single-edge razor blade scratch the sparkles on the water.

**Alpine Lake**
Watercolor on 140-lb.
(300gsm) cold-pressed Arches
10" x 4" (25cm x 10cm)

# Gradated and Streaked Washes

## Demonstration

*Bridge in County Clare* is an example of simplifying a subject. Everything about this subject was paintable. The trees, stream, bridge or meadow could have been the focal point for a painting. A small pencil sketch helped me decide on what to include in my painting.

When I travel, a good camera with a zoom lens helps me compose my paintings. I can zoom in or out on a subject until I find a nice composition. The photos do not replace a sketch. Both are tools to be used to achieve a successful painting. I still have to interpret what I see. I must use good composition, color and values to get my ideas to work.

## Materials

*Paint*
    Brown Madder
    Burnt Sienna
    Cobalt Blue
    French Ultramarine
     Blue
    Raw Sienna
    Sap Green

*Brushes*
    Flats:
      1½-inch (38mm)
      1-inch (25mm)
      ¾-inch (19mm)
      ½-inch (12mm)
    Rounds:
      Nos. 2, 4, 6 and 8

*Other*
    140-lb. (300gsm) cold-
      pressed Arches
    Drawing board
    HB to 2B pencil
    Masking tape
    Palette
    Palette knife
    Paper towels or tissues
    Ruler
    Water

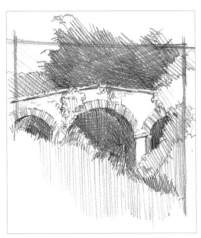

### Step 1 ~ Compose a Sketch

Try a quick pencil sketch to help you decide how to approach the painting. Keep the sketch simple and use it to indicate what wash you will use.

### Step 2 ~ Paint the First Wash

Paint the bridge using a thin wash of Burnt Sienna, Raw Sienna and Cobalt Blue. Next paint the sky with a gradated wash of Cobalt Blue and Brown Madder. The grass in the foreground is a wash of Sap Green, Raw Sienna and French Ultramarine Blue. Using the 1-inch (25mm) flat, drag this color toward the bottom of the painting. As this area is drying continue to drag additional color into the wash.

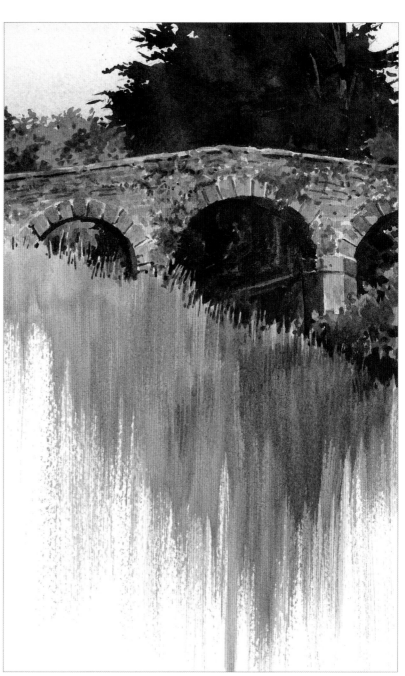

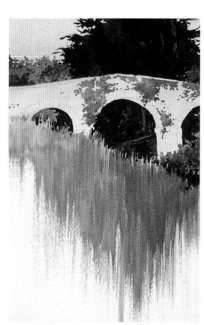

## Step 3 ~ Add Detail

Start to add detail to your painting. For the background trees use a wash of Sap Green, French Ultramarine Blue and Brown Madder.

## Final

The darker texture on the bridge is Brown Madder and Cobalt Blue. Remember that dark and light values are important features of this painting. Control these values as you work through the painting. Refer to your pencil sketch for help.

**Bridge in County Clare**
Watercolor on 140-lb.
(300gsm) cold-pressed Arches
8" x 5" (20cm x 13cm)

# Gradated and Wet-Into-Wet Washes

## Demonstration

I like to call paintings like this my therapeutic paintings. After I've completed a complicated piece, a painting like *Shorebirds* helps me loosen up. I am never exactly sure what will happen with the washes. I like to call these washes *controlled accidents*. This allows me the freedom to alter and adjust the washes as they are drying.

I try to let washes complement each other. The soft gradated sky and the wet-into-wet foreground allows me to use a busy midground. The shorebirds help tell a story and bring a focal point to the painting.

## Materials

*Paint*
> Burnt Sienna
> Cobalt Blue
> French Ultramarine
>   Blue
> Permanent Rose
> Raw Sienna
> Viridian

*Brushes*
> Flats:
>   1½-inch (38mm)
>   1-inch (25mm)
>   ¾-inch (19mm)
>   ½-inch (12mm)
> Rounds:
>   Nos. 2, 4, 6 and 8

*Other*
> 140-lb. (300gsm) cold-
>   pressed Arches
> Craft knife
> Drawing board
> HB to 2B pencil
> Masking tape
> Palette
> Paper towels or tissues
> Ruler
> Water

### Step 1 ~ Complete a Drawing and Apply the First Wash

Do a quick pencil drawing to indicate where the white water will be. Completely soak the paper with clean water. Use Cobalt Blue and Permanent Rose for the sky. Gradate the wash but leave the painting flat. Paint the areas between the white water with a wash of Cobalt Blue, Viridian and Permanent Rose. Brush a few strokes of this color into the foreground. Now add strokes of a Raw Sienna and Permanent Rose mixture to the foreground. Allow these strokes to blend together.

### Step 2 ~ Define the Waves

Use your 1-inch (25mm) flat to lift color from the area of the foam. Use a paper towel or tissue to lift color from the same area. This will leave a nice broken-edge effect on the wave. In the foreground use the 1-inch (25mm) flat to lift lines out of the wet-into-wet wash. To darken the curl of the waves use a mixture of Cobalt Blue, Viridian and Permanent Rose. The brushstroke should follow the curve of the wave.

### Step 3 ~ Add the Shorebirds

Paint the shorebirds using a Burnt Sienna wash. After they dry use a wash of Burnt Sienna and French Ultramarine Blue to darken them.

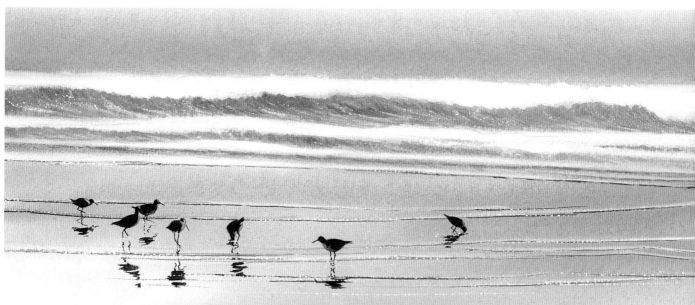

### Final

Add more value to the ripples in the foreground and paint the reflections. After the painting is dry use a craft knife to scratch sparkles on the water.

**Shorebirds**
Watercolor on 140-lb.
(300gsm) cold-pressed Arches
6" x 15" (15cm x 38cm)

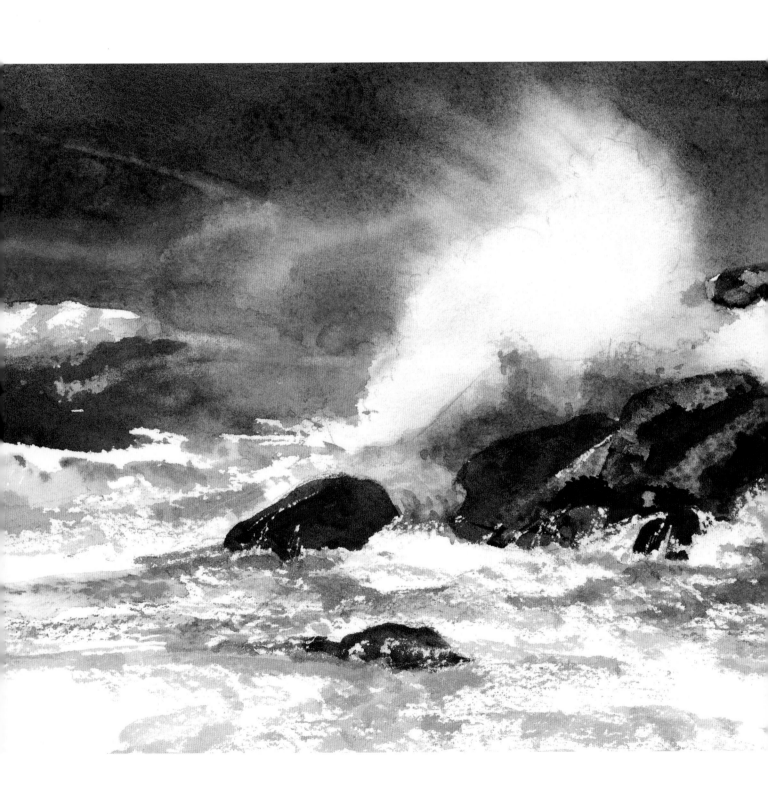

Creating textures is limitless. The only thing that stops you is your imagination. I was discussing textures with a fellow artist and asked what method he would use to paint straw. The next time we got together he had created this incredible painting. He had cut fishing line into various lengths and dropped them on the painting surface. He then filled small spray bottles with various colors and misted the paper with each color. After all had dried, he removed the pieces of cut line and painted the negative areas between the texture. It was the perfect texture for straw. I walked away knowing there is always more to learn.

Before I start painting there are a few things I like to do. I check to see that I have clean water, brushes and a palette with plenty of paint. Next, I study my reference or subject to see what textures I need to create and what washes I want to use. Brushes and paper towels are often all that will be necessary. I do not want to interrupt my painting to find the correct tool to create a texture. Timing is always critical.

An exciting aspect of watercolor is the spontaneity involved. The use of creative techniques in developing textures is an important aspect of this spontaneity. You have limitless choices of how to develop textures. You must know how wet to make the paper, how much pigment to use, what type of wash and which tool to use to create the texture. I find small studies are an essential part of the learning process. Salt is a great example of texture variation I can get. When the wash is wet large blooms develop. As the paper dries small snowflakes appear. The texture is also influenced by the quantity of salt applied. I always brush the salt from my painting when it is dry. I could go on and on about texture, but practice is the best teacher!

**Storm Waves**
Watercolor on 140-lb.
(300gsm) cold-pressed Arches
5" x 8" (13cm x 20cm)

# Texture Studies

Many different textures can be created with watercolors. Try these techniques so you can learn how the paint reacts with each one. These are just the beginning—as you paint and experiment you can create your own textures.

**Flat Wash and Lifting**
Three lifting methods are shown from top to bottom. Top: Use edge of brush. Center: Scrub with brush. Bottom: Use paper towel.

**Spattered Paint on a Flat Wash**
Spatter paint on very wet surface.

**Plastic Wrap on a Flat Wash**
Place plastic wrap on wet wash and allow to dry.

**Streaked Wash**
Top: Stroke a brush on wet surface. Bottom: Stroke a brush on dry surface.

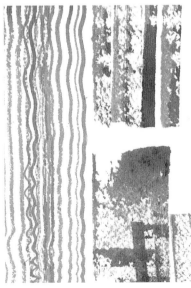

**Dry Brush**
Left side: Fan brush texture. Right side: Edge of mat board.

**Wet-Into-Wet Wash With Salt**
Apply salt onto very wet paint.

**Water Spattered on a Gradated Wash**

Top: Spatter water and allow to run. Bottom: Spatter paint with toothbrush on dry surface.

**Alcohol Spattered on a Gradated Wash**

Use 1-inch (25mm) flat to spatter alcohol.

**Paint and Water Spattered on Dry Paper**

Use a brush filled with paint followed by a brush filled with clean water.

**Wet-Into-Wet Wash With Masking Fluid**

Apply masking fluid before wash and allow to dry.

**Wet-Into-Wet Wash and Palette Knife**

Top: Use edge of knife. Center: Use tip of knife. Bottom: Use flat side of knife.

**Natural Sponge**

Top: Apply yellow with sponge. Center: Apply sponge texture to a dry surface. Bottom: Apply red over yellow with sponge.

# Palette Knife and Salt
## Mini-Demonstration

Two washes are used to create this study. First I painted the rocks using a flat wash of Cobalt Blue, Cerulean Blue and Brown Madder. When this wash became damp and lost its wet look I used a palette knife to squeegee the paint away. If the wash is too wet it will fill back in. If it is too dry it will not work. As you squeegee the paint away, use a paper towel or tissue to absorb the excess paint that builds up. After the rocks dried I painted the shadows using a French Ultramarine Blue and Brown Madder mixture.

The background is a wet-into-wet wash. Use Olive Green and Burnt Sienna on a very wet surface. As the wash was drying I sprinkled salt across the surface. When the wash was almost dry I used the tip of the palette knife to scratch in the branch and grass textures. When the painting is dry, brush away the salt. A few brush-strokes to finish the grass and limbs and the painting is complete.

A palette knife is a versatile tool; however, its use can damage the surface of some papers. 140-lb. (300gsm) cold-pressed Arches stands up well to this abuse.

## Materials

*Paint*
- Alizarin Crimson
- Brown Madder
- Burnt Sienna
- Cerulean Blue
- Cobalt Blue
- French Ultramarine Blue
- Olive Green

*Brushes*
- Flats:
    - 1½-inch (38mm)
    - 1-inch (25mm)
    - ¾-inch (19mm)
    - ½-inch (12mm)
- Rounds:
    - Nos. 2, 4, 6 and 8

*Other*
- 140-lb. (300gsm) cold-pressed Arches
- Drawing board
- HB to 2B pencil
- Masking tape
- Palette
- Palette knife
- Paper towels or tissues
- Ruler
- Salt
- Water

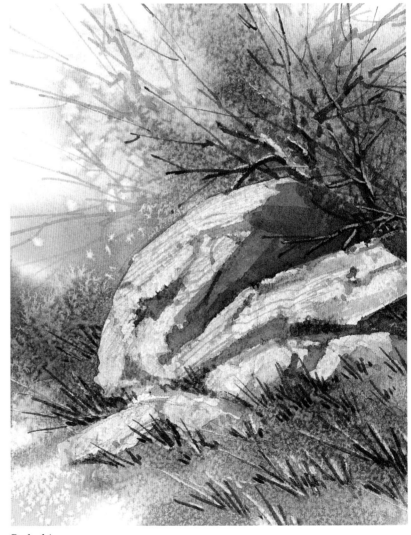

**Rock of Ages**
Watercolor on Arches 140-lb.
(300) cold-pressed paper
7" x 5" (18cm x 13cm)

### Step 1 ~ Apply the Wash

Saturate the wash area with water. Use the 1-inch (25mm) flat to apply strokes of Burnt Sienna and Olive Green and allow the colors to mix. Add French Ultramarine Blue to bring a dark value into the wash.

### Step 2 ~ Sprinkle Salt

As the wash is drying sprinkle it with salt. Allow this area to continue drying before you use the palette knife. When it is slightly damp, use the tip of the knife to scrape out the grass and branches. Remember, if the area is too wet or too dry, this process will not work.

### Final

When the painting is dry, brush away the salt. The salt has acted like small sponges, absorbing water and pigment and leaving a wonderful texture. The last step is to use your brush and accent or extend the grass and branches.

### Step 1 ~ Apply a Flat Wash

Start a flat wash with a mixture of Cobalt Blue, Cerulean Blue and Alizarin Crimson. When you have a nice flat wash, check the surface to see how wet the wash is. Starting from left to right use the tip of the palette knife and make a few lines. If the surface is very wet the lines will become dark.

### Step 2 ~ Palette Knife as a Squeegee

When the surface has lost its sheen and is soft looking, use the edge of the palette knife like a squeegee and pull it across the wash. Use a paper towel or tissue to absorb the excess paint. You have now created the highlights for the rocks. Use French Ultramarine Blue and Alizarin Crimson for the shadow.

### Final

Wait a few minutes and try the process again. If the surface is now slightly damp the lines will not fill back in.

# Palette Knife and Masking Fluid

## Mini-Demonstration

As I drove down a narrow English country lane, the side mirror of the car cut a groove into the hedge that covered a stone wall along the road. At the time I did not appreciate the textures going past the window. I just did not want the car to become part of those textures! Later, when I had time to think about what I had seen, *Stone Walls and Country Flowers* became a great texture study.

I used a medium-value flat wash of Cobalt Blue, Brown Madder and Burnt Sienna for the rock area. I did a loose drawing to indicate where the rocks would be placed. I waited until the wash lost its shine and quickly used the palette knife. I used the knife like a squeegee and followed the shape of each rock. When this area dried I used the brush to add value and texture. I used Brown Madder, French Ultramarine Blue and Burnt Sienna for the shadows.

The foliage is a flat wash of Olive Green, Sap Green and Burnt Sienna. First, I masked the flowers out using masking fluid. After this dried I painted a flat green wash. When this wash dried I painted the negative areas around each leaf. In the final step I removed the masking agent and painted the flowers. As the English say, "Give it a go!"

***Stone Walls and Country Flowers***
Watercolor on 140-lb.
(300gsm) cold-pressed Arches
8" × 4" (20cm × 10cm)

## Materials

*Paint*
  Brown Madder
  Burnt Sienna
  Cobalt Blue
  French Ultramarine
    Blue
  New Gamboge
  Olive Green
  Sap Green

*Brushes*
  Flats:
    1½-inch (38mm)
    1-inch (25mm)
    ¾-inch (19mm)
    ½-inch (12mm)
  Rounds:
    Nos. 2, 4, 6 and 8

*Other*
  140-lb. (300gsm) cold-
    pressed Arches
  Drawing board
  HB to 2B pencil
  Masking fluid
  Masking tape
  Old synthetic brush
  Palette
  Palette knife
  Paper towels or tissues
  Ruler
  Salt
  Water

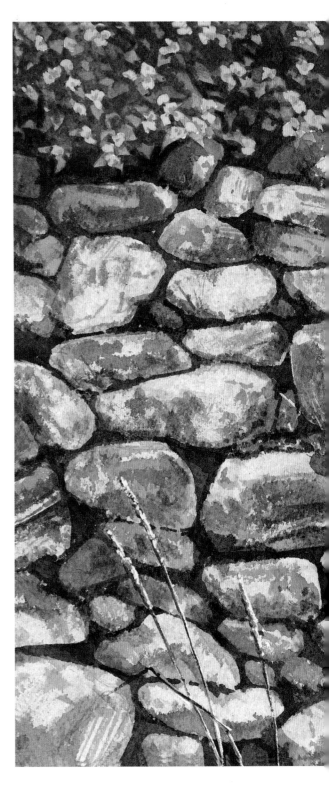

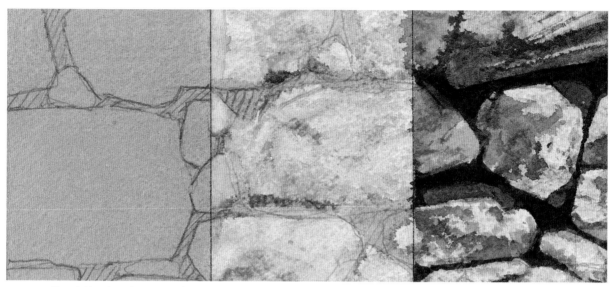

### Step 1 ~ *Pencil Sketch and First Wash*

Start the rock wall by using a flat wash of Cobalt Blue, Brown Madder and a touch of Burnt Sienna. Make sure your pencil drawing is strong enough to show through the wash.

### Step 2 ~ *Squeegee the Rocks*

Allow the wash to dry a little. Squeegee out the rocks with the edge of the palette knife. As you squeegee the paint away, use a paper towel or tissue to absorb the extra paint that builds up.

### Final

After this area has dried use a no. 4 or 6 round and add texture. The dark shadow is used to define the shape of each rock. Use a mixture of French Ultramarine Blue, Brown Madder and Burnt Sienna for this dark value.

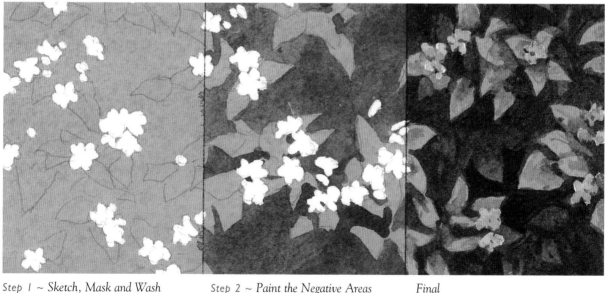

### Step 1 ~ *Sketch, Mask and Wash*

Draw a dark sketch of the flowers and leaves. Use a masking fluid to paint the flowers. Let dry. Paint a flat wash using Olive Green, New Gamboge and Sap Green. Let dry.

### Step 2 ~ *Paint the Negative Areas*

Paint the areas around the prominent leaves using a wash of Sap Green, Burnt Sienna and French Ultramarine Blue. Paint the negative areas around the next layers of leaves.

### Final

Remove the masking agent and paint the flowers using New Gamboge. Be sure that the dark shadows of the foliage and rocks are the same value.

# Dry Brush, Spatter and Natural Sponge

## Mini-Demonstration

*Seen Better Days* was from an old building in Jerome, Arizona. The structure was abandoned and falling apart but offered much to paint. My first thought was to stand back and paint the entire landscape and building. As I studied it more closely the variety of textures told a better story of being old and weathered by time. Looking more closely at subjects often presents more dramatic compositions. Bold shapes with strong negative areas are more easily seen. Shadows begin to play a more important role in the painting. An old broken window with splintered wood, a rusty drainpipe with strong cast shadows, or a rusty bucket hanging from a nail all offer potential paintings—paintings missed, if only viewed from a distance.

I started *Seen Better Days* by developing a strong composition. It was important that the shadows help define the shape of the old weathered wood. I used a flat pale wash of Cobalt Blue, Alizarin Crimson and Raw Sienna for the wood. The shadows and texture are the same color but less diluted. The old bolt and nails are painted using Burnt Sienna and Cobalt Blue. I started the wall with a very pale flat wash of Burnt Sienna and Raw Sienna. I used a natural sponge to create the texture. I painted the shadows on the wall with a wash of Winsor Blue and Permanent Rose. Look for the unusual or dramatic and you will always find subjects to paint.

## Materials

*Paint*
- Alizarin Crimson
- Burnt Sienna
- Cobalt Blue
- Permanent Rose
- Raw Sienna
- Winsor Blue

*Brushes*
- Fan brush
- Flats:
  - 1½-inch (38mm)
  - 1-inch (25mm)
  - ¾-inch (19mm)
  - ½-inch (12mm)
- Rounds:
  - Nos. 2, 4, 6 and 8

*Other*
- 140-lb. (300gsm) cold-pressed Arches
- Drawing board
- HB to 2B pencil
- Masking fluid
- Masking tape
- Natural sponge
- Old synthetic brush
- Palette
- Palette knife
- Paper towels or tissues
- Ruler
- Water

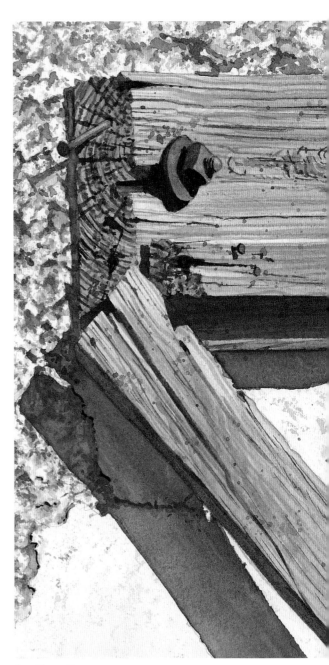

**Seen Better Days**
Watercolor on Arches 140-lb. (300gsm) cold-pressed paper
8" x 5" (20cm x 13cm)

**Step 1 ~ Wash and Initial Dry Brush**

Start with a flat wash of Cobalt Blue, Alizarin Crimson and Raw Sienna. Keep this wash light in value and allow it to dry completely. Use a 1-inch (25mm) flat to lift highlights out of the wash. A flat wash of this same mixture, but less diluted, is used to indicate the shadow.

**Step 2 ~ Use the Fan Brush**

Use a fan brush to lightly pull the shadow color in the direction of the wood grain.

**Final**

With a no. 4 round darken some of the fan brush texture. This acts as shadow on the wood grain texture. Next, drybrush a light Burnt Sienna wash on selected areas and allow this to dry. Spatter across the surface of the wood with the 1-inch (25mm) flat. Practice this step first on scrap paper to see how much paint is in your brush.

**Step 1 ~ Apply the Wash and Sponge**

To create the texture on the wall, start with a very thin or diluted wash of Burnt Sienna, Raw Sienna and Cobalt Blue. Allow this to dry completely. With this same color, but less diluted, load a natural sponge. Now gently dab the surface and allow this texture to dry.

**Step 2 ~ Apply the Second Sponge Layer**

Mix a combination of Cobalt Blue, Permanent Rose and Burnt Sienna. Gently sponge the desired area with a diluted mixture of this color. Allow this texture to dry.

**Final**

Load your sponge with this blue-gray color at full intensity. Gently apply this texture. It is important not to overdo this step. This value acts as the shadow of your previous textures. Practice on scrap paper, if necessary.

# Gradated Washes and Salt

## Mini-Demonstration

Paintings such as *Snow Storm* remind me how versatile and enjoyable watercolors can be. I started the painting with a gradated wash, using Winsor Blue, French Ultramarine Blue and Alizarin Crimson. As the wash was drying I sprinkled salt on the surface. When the wash was dry I brushed the salt off. The next step was to paint the trees in the background. I used my 1-inch (25mm) flat to spatter the texture in the foreground. I always do this first on scrap paper to see how much paint is in the brush. The weeds can be painted with a brush or palette knife. The knife has a different texture than a brush. I painted the shadows last, making sure they followed the contour of the land.

### Materials

*Paint*
> Alizarin Crimson
> Burnt Sienna
> French Ultramarine
>   Blue
> Winsor Blue

*Brushes*
> Flats:
>   1½-inch (38mm)
>   1-inch (25mm)
>   ¾-inch (19mm)
>   ½-inch (12mm)
> Rounds:
>   Nos. 2, 4, 6 and 8

*Other*
> 140-lb. (300gsm) cold-
>   pressed Arches
> Drawing board
> HB to 2B pencil
> Masking fluid
> Masking tape
> Natural sponge
> Old synthetic brush
> Palette
> Palette knife
> Paper towels or tissues
> Ruler
> Salt

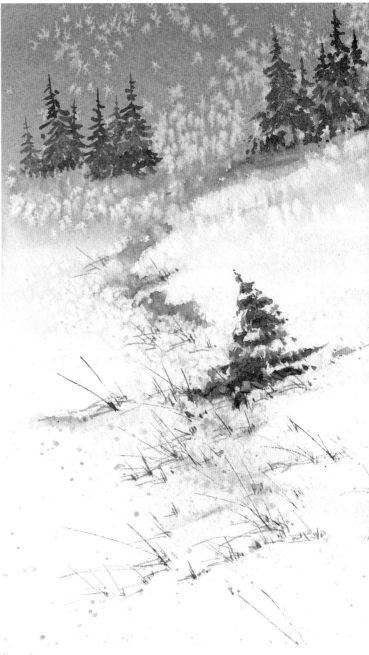

**Snow Storm**
Watercolor on 140-lb.
(300gsm) cold-pressed Arches
8" x 5" (20cm x 13cm)

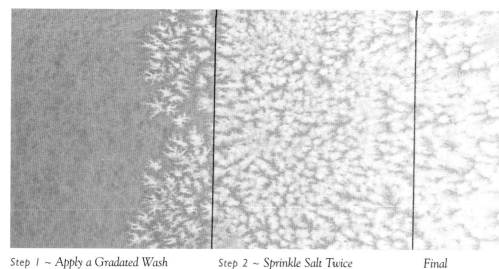

**Step 1 ~ Apply a Graded Wash**

Start a gradated wash with a wet surface. Use a mixture of Winsor Blue, French Ultramarine Blue and Alizarin Crimson.

**Step 2 ~ Sprinkle Salt Twice**

Sprinkle salt on the wash in three steps. When the wash is very wet sprinkle crystals across one area. Wait until the wash is damp. It will lose its shine. Apply more salt.

**Final**

Just before the wash dries sprinkle the last application of salt. There should be a gradual change of texture. Do not forget to brush the salt off the surface.

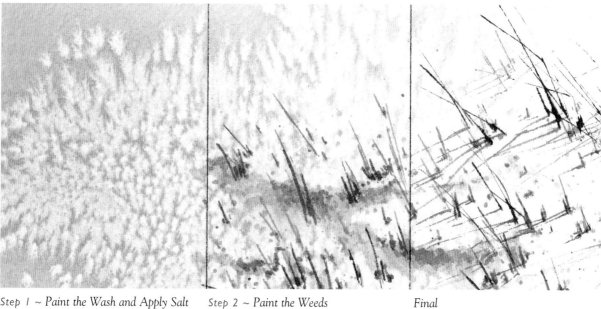

**Step 1 ~ Paint the Wash and Apply Salt**

Paint the gradated wash with salt and allow it to dry.

**Step 2 ~ Paint the Weeds**

Mix Burnt Sienna and French Ultramarine Blue. Load the edge of your palette knife with a bead of paint. Pull the edge of the knife across the paper to leave a thin line of paint. This creates a different texture than a brushstroke. Use a no. 4 round for the weeds.

**Final**

Carefully spatter the wash with paint. Use a French Ultramarine Blue and Alizarin Crimson mixture for the shadows. Remember to follow the contour of the land when painting shadows.

# Gradated Wash and Lifting

## Mini-Demonstration

A painting does not have to be complicated or tightly rendered to be successful. A painting that has a lot of impact or drama is often remembered longer than one that is tightly rendered. I will recall the golden sunset far longer than the pebbles on the beach.

As I look for subject matter to paint I try to keep an open mind about what I see. A large landscape may first catch my attention. Then I study the midground and finally, the foreground. I try to visualize what area of the scene will tell the story best.

*Summer Gold* focuses on the midground. I used two gradated washes to capture the mood of the day. I did not want to overwork the textures. I used the impact of color to capture the attention of the viewer. With a 1-inch (25mm) flat I lifted out the ripples on the water.

## Materials

*Paint*
- Alizarin Crimson
- Burnt Sienna
- Cadmium Red Medium
- Cobalt Blue
- French Ultramarine Blue
- New Gamboge
- Sepia

*Brushes*
- Flats:
  - 1½-inch (38mm)
  - 1-inch (25mm)
  - ¾-inch (19mm)
  - ½-inch (12mm)
- Rounds:
  - Nos. 2, 4, 6 and 8

*Other*
- 140-lb. (300gsm) cold-pressed Arches
- Craft knife or single-edge razor blade
- Drawing board
- HB to 2B pencil
- Masking tape
- Palette
- Palette knife
- Paper towels or tissues
- Ruler
- Water

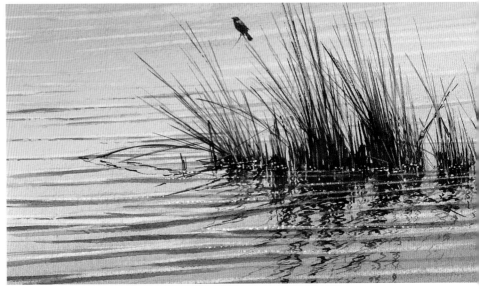

**Summer Gold**
Watercolor on 140-lb.
(300gsm) cold-pressed Arches
5" x 10" (13cm x 25cm)

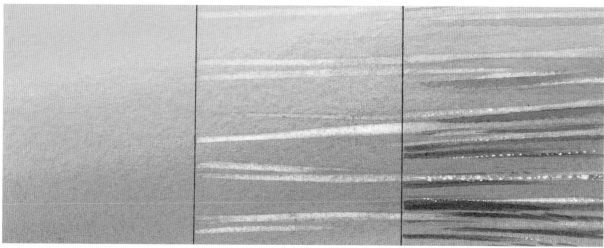

### Step 1 ~ Apply Both Gradated Washes

Saturate the paper with clean water. Mix New Gamboge and Cadmium Red Medium for the sky. Even out the wash by tilting your painting to eliminate any brushstrokes. While still wet, apply a wash of Cobalt Blue and Alizarin Crimson. Repeat the first wash.

### Step 2 ~ Lift Out Color

After the two gradated washes have dried use a 1-inch (25mm) flat to lift out color. Wet the brush and squeeze out the excess water. Gently scrub the surface. The damp brush will act as a sponge and lift out the color. Rinse and clean your brush throughout the process.

### Step 3 ~ Paint the Shadows

Lightly paint the shadows of the ripples. Use different values to do this. The sparkle is achieved with the point of a craft knife or single-edge razor blade.

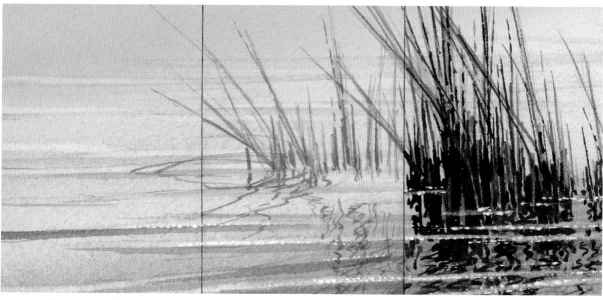

### Step 4 ~ Draw the Reeds

Draw the reeds on top of the wash. The drawings of the reeds could be done before you start the washes or after. Do what feels most comfortable. Finish lifting or adding shadows to the ripples.

### Step 5 ~ Paint the Reeds

Use a light value of Burnt Sienna to paint the reeds. This will capture the golden glow of the backlighting.

### Final

Use Burnt Sienna, French Ultramarine Blue and Sepia for the darks. Lift out color later. Paint the reflections. Allow it to dry. Scratch sparkles where the reeds touch the water to separate the reflections from the subject.

# Wet-Into-Wet Wash

## Mini-Demonstration

The wet-into-wet wash should be thought of as a texture. As a background it can be used as a vignette, a soft underpainting of the subject, or the bold blending of color on the subject. Use this wash for the soft blending in the background. It will complement the detail of the main subject.

Flowers are always a great subject to paint. They offer a wide range of shapes, colors and textures. They can be painted from a distance as an arrangement or close up for impact. I like to use a wet-into-wet wash for the underpainting of the flowers. *Fuchsia* was painted using that method. I like to paint the subject first. This allows me to decide what colors and values will be used in the background to complement the subject.

## Materials

*Paint*
- Alizarin Crimson
- Cadmium Red Medium
- Cobalt Blue
- French Ultramarine Blue
- Permanent Rose
- Winsor Green

*Brushes*
- Flats:
    - 1½-inch (38mm)
    - 1-inch (25mm)
    - ¾-inch (19mm)
    - ½-inch (12mm)
- Rounds:
    - Nos. 2, 4, 6 and 8

*Other*
- 140-lb. (300gsm) cold-pressed Arches
- Drawing board
- HB to 2B pencil
- Masking tape
- Palette
- Palette knife
- Paper towels or tissues
- Ruler
- Water

*Fuchsia*
Watercolor on 140-lb. (300gsm) cold-pressed Arches
8" x 5" (20cm x 13cm)

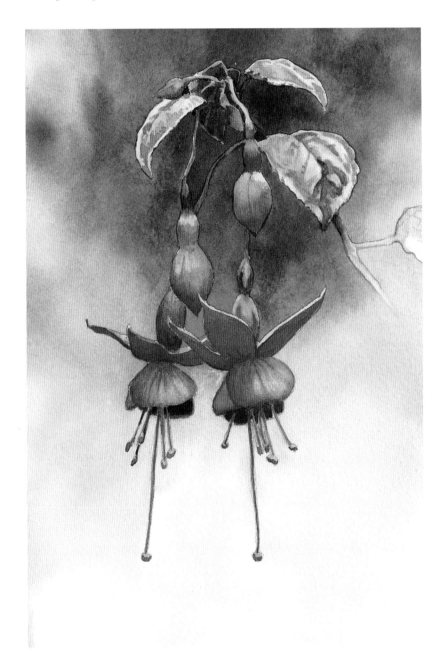

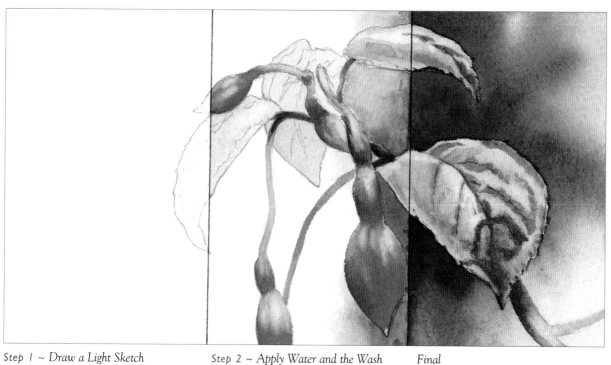

### Step 1 ~ Draw a Light Sketch

Start your painting with a pencil drawing and indicate where the shadows will be painted.

### Step 2 ~ Apply Water and the Wash

Paint the subject with clear water and allow this to soak in. Have your color mixed on the palette. Starting with the lightest value start to paint your subject. As this wash is drying add the darker values. Cadmium Red Medium and Permanent Rose were used for the lighter values. Cobalt Blue was added to darken the wash.

### Final

You must paint quickly or areas will dry too soon. Areas can be gently scrubbed to lift out highlights. The background is a texture. First, wet the area with water. Be careful as you paint up to the edge of the subject. Have a mixture of French Ultramarine Blue, Alizarin Crimson and Winsor Green ready on your palette. Using these colors, paint into the background and let the brushstrokes soften. Keep adding to this wash to darken areas. This soft texture will complement the detail of the subject.

# Wet-Into-Wet With Lifting

## Mini-Demonstration

This painting was used as a Christmas card for the National Wildlife Federation. The wet-into-wet wash was used to create an atmospheric softness or texture—the mist through the trees. This is the perfect wash for this subject. Have a mental image or pencil sketch of how you want this wash to work before you start.

Study how clouds, fog and mist move around a subject. I try to imagine my first brushstrokes just as an athlete visualizes how a race will be run. It is important to have a plan.

### Materials

*Paint*
 Cobalt Blue
 French Ultramarine
  Blue
 Brown Madder

*Brushes*
 Flats:
  1½-inch (38mm)
  1-inch (25mm)
  ¾-inch (19mm)
  ½-inch (12mm)
 Rounds:
  Nos. 2, 4, 6 and 8

*Other*
 140-lb. (300gsm) cold-
  pressed Arches
 Drawing board
 HB to 2B pencil
 Masking tape
 Palette
 Palette knife
 Paper towels or tissues
 Ruler
 Water

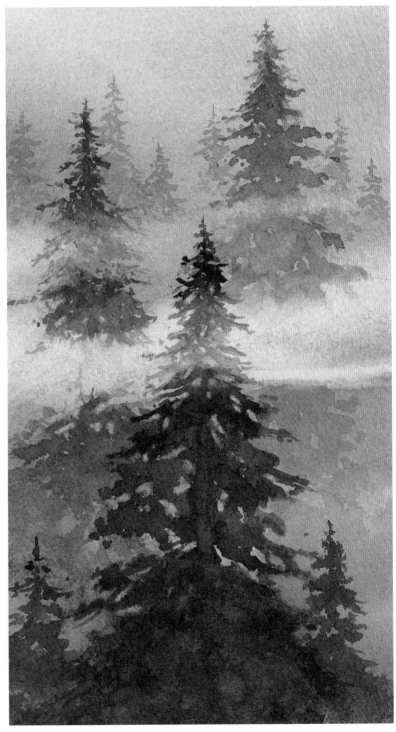

***California Redwoods***
Watercolor on 140-lb.
(300gsm) cold-pressed Arches
8" x 4" (20cm x 10cm)

### Step 1 ~ Visualize and Apply the Wash

Have a mental image or pencil sketch of how you want the wash to work. How wet the paper is will influence how the wash flows. Mix the colors you plan to use on your palette. Using the largest brush possible quickly apply the paint.

### Step 2 ~ Carefully Apply Water

If there is an area you do not want the wash to cover, use a clean brush and add water to this area. The additional water will prevent the wet-into-wet wash from filling this space. If the wet-into-wet wash has begun to dry, adding water may create a flower or balloon texture. While this can be a useful texture it may not be appropriate at this time.

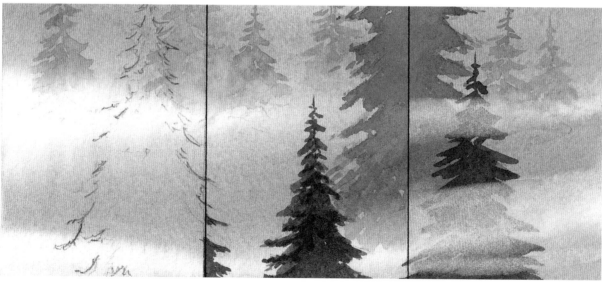

### Step 3 ~ Paint the Lightest-Valued Trees

After completing the wet-into-wet wash allow the area to dry completely. Lightly draw the trees. Start painting the lightest values on the trees first. Fade out the bottom of the trees as much as possible by adding more water to the wash.

### Step 4 ~ Paint the Middle-Valued Trees

Allow the background trees to dry. Now paint the midground trees. Overlap the trees as much as possible. The value change and overlapping will help develop the look of distance in the painting.

### Final

When the painting has dried use a damp 1-inch (25mm) flat to scrub the area of mist, removing any of the unwanted color. Gently scrub the bottom of the background trees as they fade into the mist.

# Wet-Into-Wet and Dry Brush

## Mini-Demonstration

Generally soft and flowing, the wet-into-wet technique can have a wide range of applications. I will complete a wet-into-wet wash and allow it to almost dry. Sometimes I will then apply water or another color. The almost dry wash will act as a sponge, pulling the newly applied moisture outward, creating a texture called *blooms, flowers* or *bleed back*. This technique can be used for all washes.

I often use the wet-into-wet technique for landscape paintings. I like to start with a damp surface and let the wet-into-wet underpainting show the general colors and values. If there is an area, such as a building, where pigment is not wanted I will use a paper towel or tissue to absorb the color before it dries. I can use this technique to vignette the edges of a painting. It is important to get the values correct with the first wash. I use the dry-brush technique to define areas or add texture where needed. *Rolling Hills of England* was started with a very wet wash. It is a painting of lights and darks. The wet-into-wet wash gives the colors a nice flow below the dry brush.

*Rolling Hills of England*
Watercolor on 140-lb.
(300gsm) cold-pressed Arches
5" x 8" (13cm x 20cm)

## Materials

*Paint*
Brown Madder
French Ultramarine Blue
Sap Green

*Brushes*
Flats: 1½-inch (38mm), 1-inch (25mm),
¾-inch (19mm), ½-inch (12mm)
Rounds: Nos. 2, 4, 6 and 8

*Other*
140-lb. (300gsm)
cold-pressed Arches
Drafting tape
HB to 2B pencil
Masking tape
Palette
Paper towels or tissues
Ruler
Water

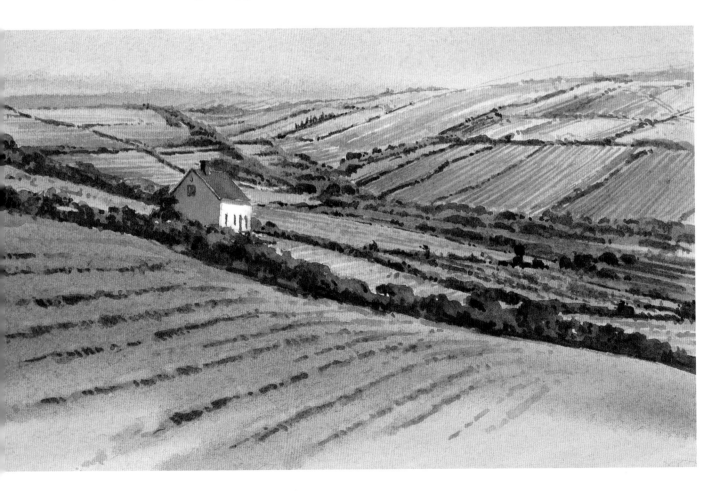

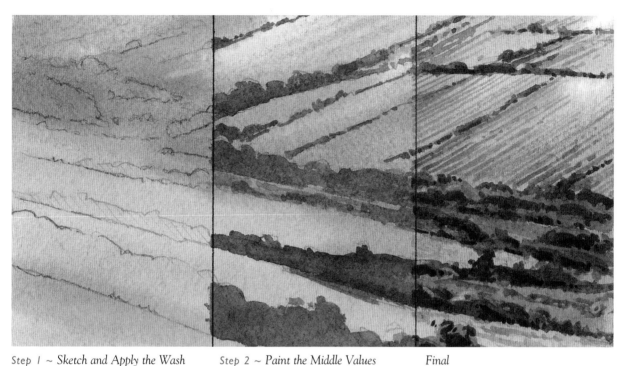

**Step 1 ~ *Sketch and Apply the Wash***

Begin with a comprehensive sketch of what you would like to paint. Have the colors mixed and ready to use on your palette. With the largest brush available quickly brush on the prepared colors. If the area is too wet the colors will run too much. If the surface is too dry you will not get the wet-into-wet effect. Timing is important. Use Sap Green, French Ultramarine Blue and Brown Madder.

**Step 2 ~ *Paint the Middle Values***

Begin to bring the middle values into the painting. Do not worry about painting any detail. That will be the last step. If there are large middle-value areas, these could be wet-into-wet washes on dry paper. Use Sap Green, French Ultramarine Blue and Brown Madder.

***Final***

Now you can add detail. The plowed fields are created using a no. 4 round pulled across the paper. The shadows are the same mixture of Sap Green, French Ultramarine Blue and Brown Madder, but less diluted. This is a traditional way of using watercolors, painting from light to dark, background to foreground.

# Streaked Wash and Dry Brush

## Mini-Demonstration

A streaked wash is really a wet-into-wet wash with direction. I like to use the streaked wash as a design element for backgrounds and foregrounds. It can indicate falling rain, wood grain or just texture. *Bridge in County Clare* (on page 75) was a streaked wash used as a foreground texture and design element. I repeat again that it is important to study the subject and develop a plan to paint by.

*In Need of Some Repair* was an old wooden fence that should have been torn down. From a distance it did not have any appeal. Up close it told another story. The old wood and nails offered a great opportunity to paint textures. Because of the grain of the wood a streaked wash was the ideal technique to use.

### Variation of the Flat Wash
The hedge is painted as a flat wash. Use Olive Green, Sap Green and French Ultramarine Blue. Use the same technique as on page 84 with *Stone Walls and Country Flowers*.

## Materials

*Paint*
> Burnt Sienna
> Cobalt Blue
> French Ultramarine
>   Blue
> Olive Green
> Permanent Rose
> Sap Green
> Winsor Green

*Brushes*
> Fan brush
> Flats:
>   1½-inch (38mm)
>   1-inch (25mm)
>   ¾-inch (19mm)
>   ½-inch (12mm)
> Rounds:
>   Nos. 2, 4, 6 and 8

*Other*
> 140-lb. (300gsm) cold-
>   pressed Arches
> Drawing board
> HB to 2B pencil
> Masking tape
> Palette
> Palette knife
> Paper towels or tissues
> Ruler
> Water

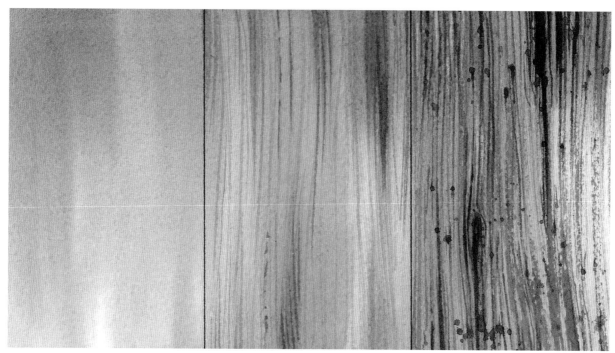

### Step 1 ~ Apply a Varied Wash

Start the painting as a wet-into-wet wash. Saturate the paper with water only in the area you plan to use texture. Use a mixture of Cobalt Blue, Permanent Rose and Burnt Sienna for the initial brushstrokes. As you work across the painting vary the quantity of each pigment. For instance, one area will have more Burnt Sienna, another area more Cobalt Blue. Direct the brushstrokes up and down.

### Step 2 ~ Drag Color Across the Wash

When the initial wash is almost dry or slightly damp, use a fan brush to drag color down the wash. This will accent the previous vertical brushstrokes. The fan brush texture will soften slightly.

### Final

To finish the old wood texture, allow the wash to dry. With a mixture of French Ultramarine Blue, Permanent Rose and Winsor Green lightly drag a no. 2 fan brush down the wash. Do not overpaint it. With a no. 2 or no. 3 round darken some of the lines. The final step is to use a damp 1-inch (25mm) flat and lightly drag it over the wash. Practice on scrap paper first. If the brush is too wet you will get a solid brushstroke. I almost forgot! Use the same brush to spatter the area. This will give the effect of holes in the wood.

**In Need of Some Repair**
Watercolor on 140-lb.
(300gsm) cold-pressed Arches
8" x 5" (20cm x 13cm)

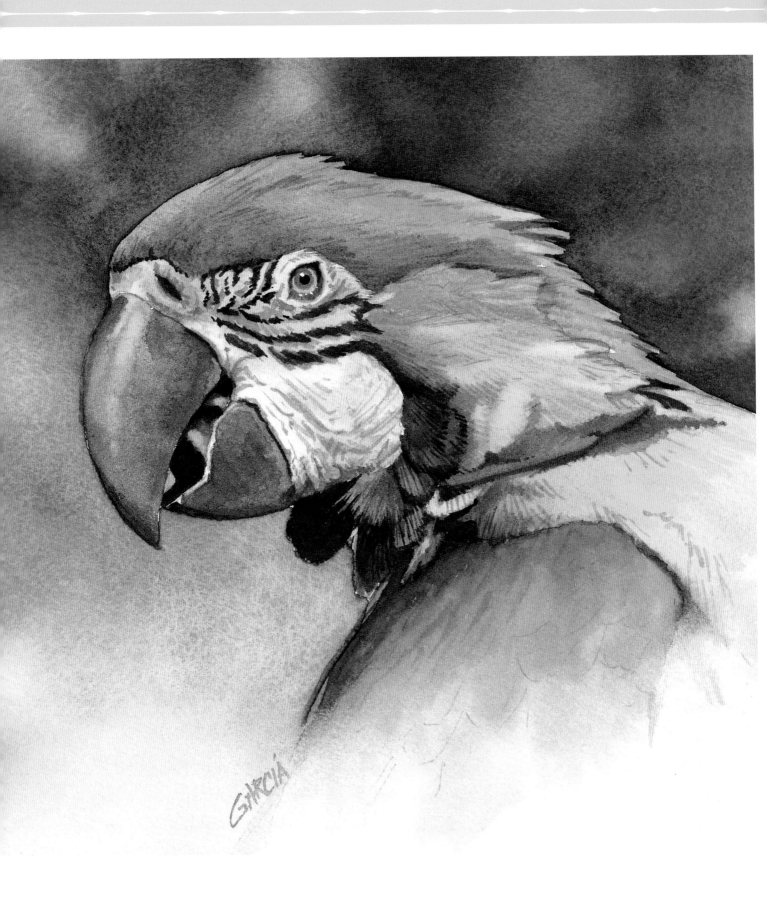

### Use a Controlled Wet-Into-Wet Wash

Each area of the macaw was done almost completely with a very carefully controlled wet-into-wet wash. Very little detail was incorporated into the painting. The beak, head, neck and shoulder were all started as wet-into-wet washes. The face was also a wet-into-wet wash, but I used more dry brush to show texture. Lifting brought out highlights, especially on the bill. All the shadows and color mixtures were painted as the individual areas dried. The beak was painted using French Ultramarine Blue and Brown Madder. The wash used on the head was a mixture of Raw Sienna and Burnt Sienna. The shadows were painted just before the area dried. This controlled how far the color spread. The last area to be painted was the background, using Alizarin Crimson, French Ultramarine Blue and Winsor Green.

**Macaw**
Watercolor on 140-lb.
(300gsm) cold-pressed Arches
6" x 6" (15cm x 15cm)

There are always two sides to every coin. It is that way somewhat with painting. When you are a beginning painter, the technical part is mostly one side of the coin. As you become more competent the style or emotional aspect of your work becomes the other side of the coin. Both sides play an important part of your painting abilities. The balance between the two often shifts from side to side. Generally, when you start painting the balance is weighted on the technical or learning side. That is the way it should be. Learning to paint good controlled washes will later allow you to express your ideas and emotions more easily through your paintings. A good book or instructor is important for this balance. The lessons you learn will help eliminate mistakes and shorten wasted time. The lessons you learn should also remind and help you develop your own style. Strive and challenge yourself to create this personal style. Make your work stand out from other artists. As you become more competent this challenge will become easier. The technical and emotional sides of painting will come closer together. It is exciting and gratifying when a painting is completed and it feels successful. When the painting has captured the emotion or idea you wanted to convey, then the two sides of the coin are a little more equal.

Often watercolors are worked from the background forward, light to dark and loose to tight. This is not always true. Occasionally use the basic wash differently. Initially, painting a wash can be difficult. Practice by painting samples. As you gain control of a wash, think about its application in a painting. Try confining the wash to a specific area. Choose carefully the type of wash to be used and experiment with it. The difference between the rectangular practice washes and the subject to be painted is the line drawing. The wash will work in either area.

The use of light and shadows can be thought of in much the same way. If you understand that light and shadows define shapes, then how and what you paint becomes easier. Do a painting using only the shadows. Confine the washes to only the shadow areas. If it is a portrait or building you will understand the shape because of the shadows. It will have a high contrast look. Remember, shadows follow the contour of the subject they fall on. Negative space is very apparent and can be incorporated into the composition. Contrast is created by the change in value between the light and dark side. Use the light and shadows to create drama or mood. A sunset with close values may not have high contrast, but it creates a very specific mood. Look for unusual formats and experiment with composition, but foremost imagine how the washes will be used. Will the washes be confined to specific areas or will they cover the majority of the format? Knowledge and confidence will create a well-executed painting. The challenge is to get a good balance between the technical and emotional side of painting—the two sides of the coin.

# Confining Wet-Into-Wet Washes

*Water Lilies* was painted completely by using wet-into-wet washes. After developing a composition with a rough sketch or value study, I did my drawing on 300-lb. (640gsm) cold-pressed Arches. I knew I needed the prolonged drying time that the heavier paper gives. This allowed me to paint wet-into-wet washes in confined areas more easily. Each lily pad was painted separately using Olive Green and Sap Green. The warm brown along the edge of the pads is Brown Madder.

**Pencil Sketch**
A rough pencil sketch will help you determine how to compose your painting. Many of your initial design decisions can be made at this stage.

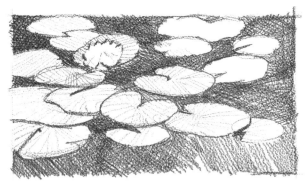

**Value Study**
Creating a value study is invaluable when composing your painting. Establishing value contrasts before you begin painting will prevent you from making mistakes when applying color.

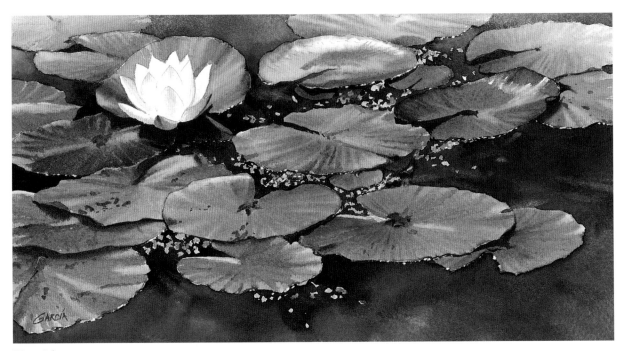

**Water Lilies**
Watercolor on 300-lb.
(640gsm) cold-pressed Arches
5" x 11" (13cm x 28cm)

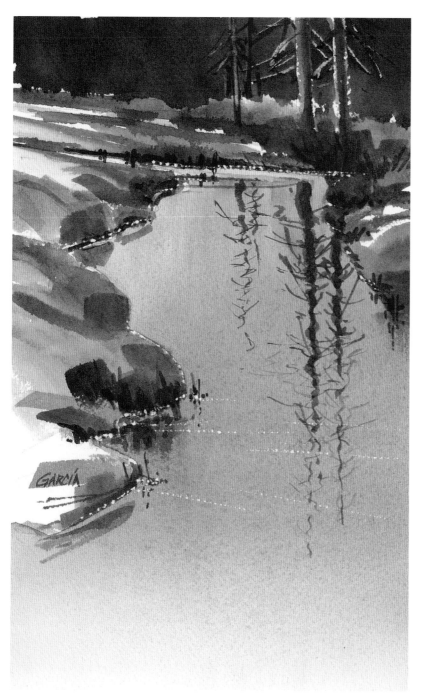

### Combining Washes is Fun

If you look at *Reflections in a Pond* as a series of washes you will see each wash is contained to a specific area. This was a fun and easy painting to do. The first and most important wash was the area of the water. Using a gradated wash of Raw Sienna and Cobalt Blue I painted it from top to bottom. After this area was totally dry the sides and midground were painted. I used quick, large brushstrokes to indicate foliage and shadows. The last wash was a dark, wet-into-wet background of French Ultramarine Blue, Alizarin Crimson and Winsor Green. This dark wash helped push the lighter value of the midground forward.

### Reflections on a Pond
Watercolor on 140-lb.
(300gsm) cold-pressed Arches
8" x 5" (20cm x 13cm)

# Wet-Into-Wet Wash

## Demonstration

*American Kestrel* is painted using wet-into-wet washes. This is the same technique as used in *Macaw* (page 100). Paintings that require accurate reference are usually done from photographs I have taken. A trip to the local zoo or animal refuge center will often provide numerous photo opportunities for future paintings. If you think you have a lot of art supplies, wait until you start adding camera equipment to your list!

I like to study the subject carefully. I look for colors that blend together. This can translate into a wet-into-wet wash. Areas that are one color may work out to be a flat wash or gradated wash. I look at the subject as areas of color and value. I forget about details until later.

I wet the area to be painted with clean water, mixing the colors on the palette as closely to the final value and color as possible. Adding color later

might muddy or overwork the area, and I can wash or glaze the shadow color later. I keep it simple and clean to have a successful painting. If the area is too wet the colors will run, if too dry hard edges will develop where they are not intended. As always, patience is a virtue and in watercolors it is a blessing.

## Materials

*Paint*
- Brown Madder
- Burnt Sienna
- Cobalt Blue
- French Ultramarine Blue
- New Gamboge
- Permanent Rose
- Sepia

*Brushes*
- Flats:
    - 1½-inch (38mm)
    - 1-inch (25mm)
    - ¾-inch (19mm)
    - ½-inch (12mm)
- Rounds:
    - Nos. 2, 4, 6 and 8

*Other*
- 140-lb. (300gsm) cold-pressed Arches
- Drawing board
- HB to 2B pencil
- Masking tape
- Palette
- Palette knife
- Paper towels or tissues
- Ruler
- Water

*Step 1 ~ Create a Sketch and Apply the First Wash*

Start the painting with an accurate line drawing. If the drawing is not correct it will not matter how well you paint the subject. The painting will not look right. After you have completed the drawing saturate the area to be painted with water. Allow this to soak in and dry to the desired dampness. Too wet and it will be difficult to control the wash. The back, head and chest are painted using Burnt Sienna, Cobalt Blue and Brown Madder.

### Step 2 ~ Paint the Shoulder, Tail and Legs

Wait until the painted areas are dry. The shoulder, tail and legs are painted as flat or gradated washes. Lift out highlights later if needed. A wash or glaze on the chest can be added to emphasize the shadow. Use Cobalt Blue and Brown Madder to paint the shoulder, and a black mixture of French Ultramarine Blue and Sepia for the tail. (Lift color out of the black to prevent the area from looking empty.) Use New Gamboge for the legs.

### Step 3 ~ Add the Dark Values

To finish painting the kestrel use French Ultramarine Blue and Sepia for the black color. This mixture will be used on the face and wing. The shadows are a mixture of Cobalt Blue and Permanent Rose. There is very little detail on the bird. Lift color out of the blacks to prevent the areas from looking empty.

### Final

The background is all wet-into-wet wash. Use Burnt Sienna and Cobalt Blue on a very wet background and allow the wash to flow freely. Pick up the painting and help this process. Be careful so the wash does not run into the kestrel. After the entire painting is dry paint the claws, tip of the beak, and wing tips.

**American Kestrel**
Watercolor on 140-lb.
(300gsm) cold-pressed Arches
6" x 8" (15cm x 20cm)

# Gradated and Wet-Into-Wet Wash

## Demonstration

Looking for things to paint can be almost as much fun as painting them. I try to look for things a little different than the obvious. Many artists will paint the old house, whereas I like to paint the broken window. Some artists will paint the fence, but I prefer to paint the old gate. Take a closer look to find the hidden story that needs to be painted.

*The Old Gate* was a story of textures. Dried and cracked paint, rusted metal and scratched wood all asked to be painted. Sandpaper, craft knife or single-edge razor blade, palette knife and sponge can all be used to create these textures. I plan the painting before I start. The shape of the fence will contain the washes, but what wash will I use? I decide to paint the boards wet-into-wet. The slats in the foreground will be glazed with a gradated wash to show the shadow. Painting a scene is like a puzzle, and I get to make and put the pieces together. Now that I have a plan of action I can begin to let the textures tell the story of the old gate.

## Materials

*Paint*
- Alizarin Crimson
- Burnt Sienna
- Burnt Umber
- Cobalt Blue
- French Ultramarine Blue
- Olive Green
- Permanent Rose
- Raw Sienna

*Brushes*
- Flats:
    - 1½-inch (38mm)
    - 1-inch (25mm)
    - ¾-inch (19mm)
    - ½-inch (12mm)
- Rounds:
    - Nos. 2, 4, 6 and 8

*Other*
- 140-lb. (300gsm) cold-pressed Arches
- Craft knife or single-edge razor blade
- Drawing board
- HB to 2B pencil
- Masking tape
- Palette
- Palette knife
- Paper towels or tissues
- Ruler
- Water

### Step 1 ~ Sketch and First Wash

Complete a pencil drawing of the fence. Indicate where the textures will be. Drag the brush filled with water over the surface of the paper. Apply the paint to these wet areas and let the color flow outward. This will create a wet-into-wet, dry-brush effect. Use Cobalt Blue, Raw Sienna and Permanent Rose.

### Step 2 ~ Emphasize the Wood Texture

While the first wash is still slightly damp add more color and texture. Use French Ultramarine Blue, Burnt Sienna and Burnt Umber. The darkest, richest color will be on the outside edge of each fence slat.

### Step 3 ~ Add Dry-Brush Texture

Allow everything to dry thoroughly. Now do some dry-brush texture. Lightly drag the brush over the surface of the paper. Let the texture of the paper do the work for you. Use the tip of a craft knife or single-edge razor blade to scratch in some white. The boards in the foreground can now be put into deep shadow. With a mixture of Cobalt Blue and Permanent Rose apply a gradated wash or glaze over the two boards. This will soften some of the texture and allow the latch to stand out a little more.

*Final*

The background is a wet-into-wet wash. Use a dark, rich mixture of French Ultramarine Blue, Alizarin Crimson and Olive Green to silhouette the fence.

**The Old Gate**
Watercolor on 140-lb.
(300gsm) cold-pressed Arches
8" x 5" (20cm x 13cm)

# Gradated, Flat and Wet-Into-Wet Washes

This was an old fishing boat in the Gulf of California. The tide had gone out and the boat was left high and dry. While the boat offered many opportunities for paintings I felt the boat's situation was the story to be told. Gradated washes created the shadows on the boat. Flat washes created the old buildings and bottom of the boat. The sky and beach were painted using wet-into-wet washes.

## Materials

*Paint*
> Burnt Sienna
> Cobalt Blue
> Permanent Rose
> Raw Sienna
> Winsor Blue

*Brushes*
> Flats:
>> 1½-inch (38mm)
>> 1-inch (25mm)
>> ¾-inch (19mm)
>> ½-inch (12mm)
> Rounds:
>> Nos. 2, 4, 6 and 8

*Other*
> 140-lb. (300gsm) cold
>> pressed Arches
> Drawing board
> HB to 2B pencil
> Masking tape
> Palette
> Palette knife
> Paper towels or tissues
> Ruler
> Water

*Step 1 ~ Draw a Sketch and Paint the Shadows and Shacks*

The washes used on the boat are gradated washes. Use Winsor Blue and Raw Sienna to indicate the shadow on the bow of the boat. Toward the bow add Permanent Rose and darken the value. Do this also on the cabin. The fishing shacks were painted with flat washes of color.

## Step 2 ~ Apply a Flat Wash

A flat wash was used for the bottom color on the boat. Flat washes were also used to indicate the shadows on the background buildings.

## Final

The sky and sand are wet-into-wet washes. Using a mixture of Burnt Sienna and Raw Sienna, create the sand by dragging the brush filled with color over the dry texture of the paper. Before this dries feed in a few strokes of Cobalt Blue and Permanent Rose mixture. Create the rock texture with a palette knife. The sky is a mixture of Cobalt Blue and Permanent Rose.

The detail of ropes and chains are the last things to paint. Lift out a little color from the windows so they do not look like empty holes. You have now painted a scene of an old fishing boat left high and dry until the tide comes flowing back.

**High and Dry**
Watercolor on 140-lb.
(300gsm) cold-pressed Arches
6" x 5" (15cm x 13cm)

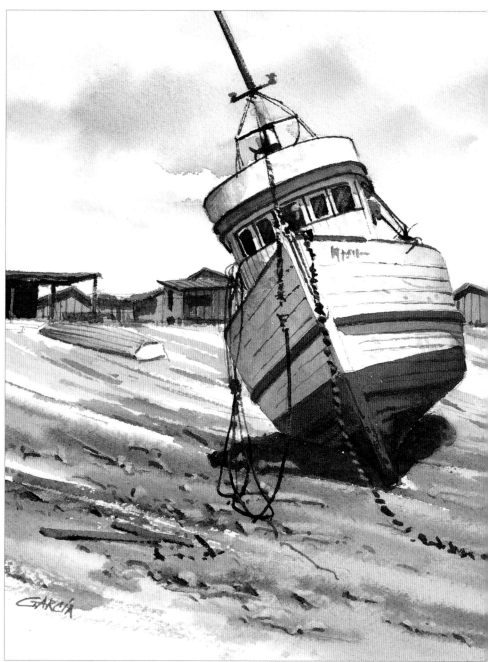

# Advanced Examples of Confining Washes

Confining washes to specific areas of your painting is not as restrictive as it may sound. It is important to study your subject and decide how you want to paint it. What wash or combination of washes will most successfully work in your painting? Use a small, quick pencil drawing or sketch to develop the composition. Study the light, shadows, texture and structure to formulate what approach to use in the painting. This process may take one or two minutes, but it will influence the success of your painting.

**Luxembourg Garden**
Watercolor on 300-lb.
(640gsm) cold-pressed Arches
9" x 11" (23cm x 28cm)

## Unexpected Painting

I was walking through the Luxembourg Garden in Paris on a cold, gray December day. I did not expect to find anything interesting to paint. As I walked around, a young French girl ran up to the fountain with a handful of dried leaves. My painting had been found.

*Luxembourg Garden* is essentially a wet-into-wet wash. The coat, hat and shoes were painted first using a very rich wash of French Ultramarine Blue and Alizarin Crimson. After these areas dried I painted the rest of the young girl. As the background wash dried, I added color around the girl. The fountain wall and ground were painted with Burnt Sienna, Cobalt Blue and Burnt Umber. I lifted out color to define the edge of the fountain. The water is a wet-into-wet wash of Cobalt Blue and Cerulean Blue.

***Waiting***
Watercolor on 140-lb.
(300gsm) cold-pressed Arches
11" x 15" (28cm x 38cm)

## Wet-Into-Wet Wash

*Waiting* is painted using wet-into-wet washes. The mountain lion is painted first with very damp wet-into-wet washes. The shadows were glazed with a wash of a Cobalt Blue and Permanent Rose mixture. The texture in the background was created with salt sprinkled into a very wet-into-wet wash. The texture on the rocks was done with salt and then a palette knife was used as a squeegee. There is very little detail in the mountain lion. A few strokes indicate the fur. It is the intensity of color and shadows that make the shape read well.

# Light and Shadows

A painting is like a good book. We all enjoy different types of stories. Action, history, romance, whatever catches our fancy. It is the same with a painting. A painting must first attract our interest. It should hold our attention and create an emotional reaction— good, bad or indifferent. Composition is the framework of the painting, but it also is like the opening paragraph for the story. It sets the direction or tempo of what we are going to see or read. Color, value, light and shadows are other design elements that help develop the composition and mood of the painting. While each element can vary in its significance, good composition will always be the most important part of the painting. Light and shadows are important implements of composition.

### Light and Shadow Create Contrast

*Room With a View* was painted because of the light and shadows. I walked past an old two-story building not seeing anything that caught my attention or that I had to paint. I took a few photos to document my trip and called it a day. When I developed the film I was in for a surprise. The old window with its cast shadows jumped out at me. I used some artistic license and added an English sparrow, changed the colors of the shadow, and with creative cropping made the painting a tall vertical. I wanted to use the strong light and shadows to emphasize the strong vertical composition of the painting.

**Room With a View**
Watercolor on 140-lb.
(300gsm) cold-pressed Arches
29" x 11" (74cm x 28cm)

### Defining Shape

The light and shadows of *Rocky Mountain High* are used to describe the shape or struc-
ture of the subject. The flat wash of the shadows lets us see the white of the snow and
the shape of the mountains. The washes do not draw attention to themselves but help
the viewer move throughout the painting.

**Rocky Mountain High**
Watercolor on 140-lb.
(300gsm) cold-pressed Arches
5" x 8" (13cm x 20cm)

# Describing Form With Shadows

## Demonstration

Flowers can be a difficult subject to paint. Because of the beauty and delicacy of the subject the structure is often overlooked. *Sexy Rexy* was painted by showing the contrast of light and shadows. The highlights bring life and brightness to the flower. The dark, rich shadows show the separation and depth of each petal. The first wash of Scarlet Lake and Permanent Rose is washed over the entire area of the drawing. This is the light underpainting for the flower. After this wash dried, flat or gradated washes were used to develop the shadows. I used a glaze of gradated wash to darken the value in the deepest shadows. The background was painted last using a very wet-into-wet wash. Olive Green, Permanent Rose, Raw Sienna, Winsor Blue and Alizarin Crimson were all used. When this wash was dry I used a plastic circle guide as a template to lift color from the background.

## Materials

*Paint*
> Alizarin Crimson
> French Ultramarine
> Blue
> Olive Green
> Permanent Rose
> Scarlet Lake
> Raw Sienna
> Winsor Blue

*Brushes*
> Flats:
>> 1½-inch (38mm)
>> 1-inch (25mm)
>> ¾-inch (19mm)
>> ½-inch (12mm)
> Rounds:
>> Nos. 2, 4, 6 and 8

*Other*
> 140-lb. (300gsm) cold-
> pressed Arches
> Drawing board
> HB to 2B pencil
> Masking tape
> Palette
> Palette knife
> Paper towels or tissues
> Plastic circle guide
> Ruler
> Water

*Step 1 ~ Draw a Sketch and Apply an Underpainting*

Start your painting with a light pencil drawing, indicating clearly where the shadows will be. Use a light or thin flat wash of a Scarlet Lake and Permanent Rose mixture as an underpainting. If it is a little too dark lift out color from where the highlights will be using a no. 4 round. Allow this wash to dry completely.

### Step 2 ~ Paint the Shadows

Begin to paint the shadows. Use the same wash of Scarlet Lake and Permanent Rose, but with less water. Paint where you have indicated the shadows. Do not worry about individual petals. These can be painted as flat or gradated washes. Do not overwork this step.

### Step 3 ~ Paint the Darkest Shadows

With a rich wash of Scarlet Lake, Permanent Rose and French Ultramarine Blue, paint the darkest shadows using a gradated wash to glaze on this color.

### Final

The background is very wet-into-wet. First brush Permanent Rose and Olive Green into separate areas of the background. Add a rich, dark mixture of French Ultramarine Blue and Alizarin Crimson. Allow the colors to mix. Pick up your painting and help this process. After this wash has dried use a circle guide to gently lift color from the background using a no. 4 or 6 round. A commercially made guide has numerous sizes from which to choose. Practice this last step on scrap watercolor paper. If a mistake is made it is difficult to correct.

**Sexy Rexy**
Watercolor on 140-lb.
(300gsm) cold-pressed Arches
5" x 7" (13cm x 18cm)

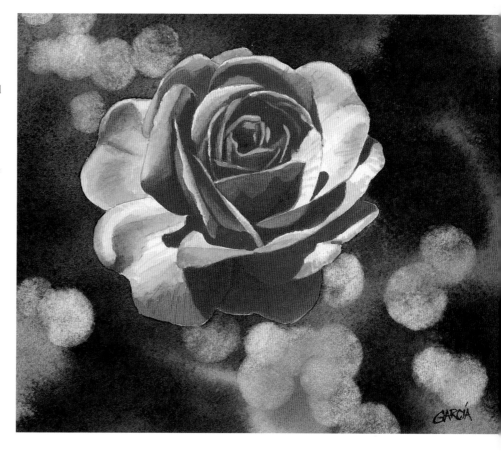

# Describing Form With Light

## Demonstration

Balboa Park in San Diego, California, was built in 1915, and originally laid out in the late 1800s. Some of the structures were built for the Panama-California Exposition. It was San Diego's opportunity to showcase the beautiful city. The park encompasses acres of gardens, eucalyptus groves, walking trails, historic buildings and museums, all quite picturesque and suitable for painting. I find that some of the most interesting subjects to paint are the details that make up a scene. *Faces of Balboa Park* is very similar to *Room With a View* (page 112). The light and shadows describe the form. There is no question that this is the ornamental capital on a pillar. The reflected light in the shadows helps bring life to the painting. This started as a wet-into-wet wash with very definite structural boundaries. The dark wet-into-wet background helps bring the pillar forward.

## Materials

*Paint*
    Alizarin Crimson
    Brown Madder
    Cobalt Blue
    French Ultramarine
     Blue
    Permanent Rose
    Raw Sienna

*Brushes*
    Flats:
        1½-inch (38mm)
        1-inch (25mm)
        ¾-inch (19mm)
        ½-inch (12mm)
    Rounds:
        Nos. 2, 4, 6 and 8

*Other*
    140-lb. (300gsm) cold-
        pressed Arches
    Drawing board
    HB to 2B pencil
    Masking tape
    Palette
    Palette knife
    Paper towels or tissues
    Ruler
    Water

**Step 1 ~ Indicate the Light and Shadow**

Start the painting with a good drawing of the pillar and its filigree. This drawing should indicate where the light and shadows fall on the column. Be sure the drawing inside the shadow is strong. You will need to see this drawing after the wash has dried. The first wash is wet-into-wet using Cobalt Blue, Permanent Rose and Raw Sienna. The Raw Sienna should be applied where there is to be reflected light.

**Step 2 ~ Middle-Valued Shadows**

Start painting into the shadows. If the pencil lines are not visible redraw them. Paint the middle values. This should be on dry paper. You will be able to control the paint and gradated values more easily.

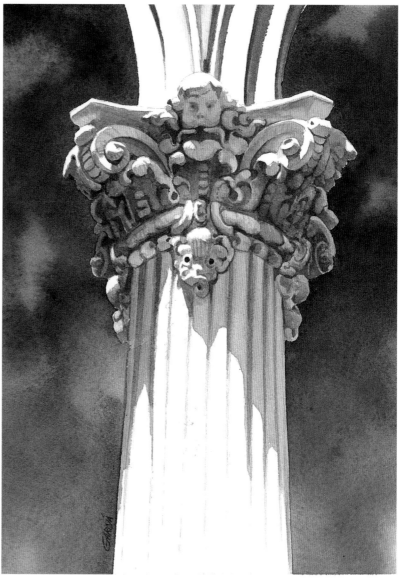

### Step 3 ~ Finish the Shadows

Paint the last darks into the shadow area. This step is where you bring out the fluting on the columns or any other detail you want to emphasize. Use a mixture of French Ultramarine Blue, Brown Madder and Cobalt Blue for the darks.

### Final

Finish the background with a rich, dark wet-into-wet wash of French Ultramarine Blue, Alizarin Crimson and Raw Sienna. This dark wash will help bring the column forward.

***Faces of Balboa Park***
Watercolor on 140-lb.
(300gsm) cold-pressed Arches
10" x 8" (25cm x 20cm)

# Washes in Specific Areas

## Demonstration

Mouser is my cat. I saw her napping on an old wicker chair and noticed the contrast of shapes and textures. I grabbed my camera before she could skitter away. That is how this painting got its start. Because of the interesting structure of the shadows I decided to paint only these shapes, using a flat wash to paint Mouser's markings. There is very little detail in the painting. The contrast of values, color and interesting cropping makes the painting read well. Generally, I do not paint cats unless they are mountain lions or bobcats! But this was fun and I may have to do more domestic cat paintings!

## Materials

*Paint*
    Burnt Sienna
    Cobalt Blue
    French Ultramarine
      Blue
    Permanent Rose
    Sepia

*Brushes*
    Flats:
      1½-inch (38mm)
      1-inch (25mm)
      ¾-inch (19mm)
      ½-inch (12mm)
    Rounds:
      Nos. 2, 4, 6 and 8

*Other*
    140-lb. (300gsm) cold-
      pressed Arches
    Drawing board
    HB to 2B pencil
    Masking tape
    Palette
    Palette knife
    Paper towels or tissues
    Ruler
    Water

### Step 1 ~ Begin With the Shadows

Begin by drawing just the shadows of the chair and the shape and patterns of the cat. A flat wash of Burnt Sienna is used for the warm color. The dark patterns are painted with a mixture of French Ultramarine Blue and Sepia. This dark mixture can be a wet-into-wet wash. Use Cobalt Blue and Permanent Rose for the shadows. Note how the shadow of the chair follows the contour of the cat.

### Step 2 ~ Finish the Shadows

Finish the shadows on the cat and start painting the shadows of the chair. This leaves an interesting pattern that complements and contrasts the shape of the cat. Use Cobalt Blue and Permanent Rose for this color. Painting only the shadows requires a strong light source.

## Final

Continue to paint the wicker chair using Cobalt Blue and Permanent Rose. Maintain the rhythmic feel of the chair by alternating the values as you go.

**Mouser**
Watercolor on 140-lb.
(300gsm) cold-pressed Arches
6" x 11" (15cm x 28cm)

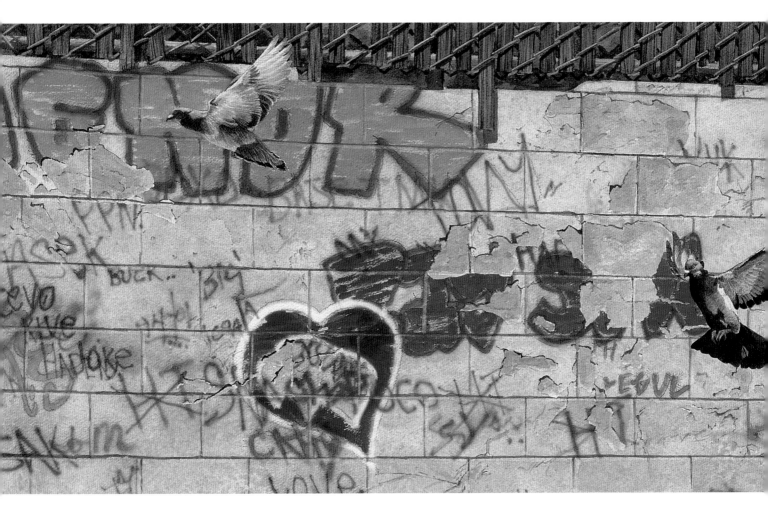

### Experiment

*Birds in the 'Hood* was an experiment. I had never used an airbrush or painted graffiti. I borrowed the necessary equipment and started to practice. The airbrush emulated the texture of spray cans perfectly. The subjects that I paint are usually not as busy and are easier to compose. Getting the reference was interesting, but that is another story. I would enjoy doing more paintings along this theme. Experimenting with color, composition and airbrush was new and challenging. If I continue more paintings of this genre I need to make sure I am not caught by the police! Just kidding!

**Birds in the 'Hood**
Watercolor on 140-lb.
(300gsm) cold-pressed Arches
11" x 29" (28cm x 74cm)

No matter how long you have been painting you should challenge yourself. Your confidence and knowledge will continually evolve. The more you learn, the more confident you become. This evolution does not just happen—it takes a conscious effort. Practice, practice, practice is the anthem for success. With this anthem comes a challenge to launch out.

Begin to develop your own look or style. This is the difficult part of your journey. The easy way out is to paint like your mentor or the lessons in a book. You owe it to yourself to go beyond. You can be satisfied with

what you did today, but always say to yourself, "Tomorrow I will do a little bit better." In this effort to develop a style be open to new ideas, techniques and materials. Do you prefer traditional methods or a more avant-garde approach to painting? Study other artists' work and decide what you like or dislike about their technique. The key to your enjoyment will be to find what works for you.

Sketching is a valuable part of your painting education. As you become comfortable and familiar with watercolor techniques, sketching will help broaden your approach to painting.

The camera is a wonderful tool for recording information. Disadvantages might be that it records everything, limits ideas for composition or misses the mood you want to capture. Sketching will help eliminate these restrictions. If you have taken the time to do a quick study you will remember the particulars. How cold, wet or sunny it was will be etched in your mind. Sketching will eliminate unwanted information and help compose your work. It will help create ideas for future paintings and may be successful enough to frame and hang.

You have taken the time to understand and learn the basics of watercolor. Now it is time to take the next step—experiment. Painting should be a continual evolution of growth. Using new ideas, techniques and products are as important as the first wash you put to paper. When a technique or style works well it is difficult to leave this comfort zone. Experimenting may lead to mistakes but it may also open the door to your imagination. This is the time to play.

# Texture

Experiment by trying to develop different textures. Use your imagination and think how the texture could be used in a painting. Try materials you have not used before. Wax might be used for splashing water; masking tape can be torn or cut to be used as a resist. Try painting with the edge of mat board. Be creative and see what you come up with. Do the same textures on different surfaces. Observe the differences.

### Wax
Wax or paraffin creates a resist against watercolor paints.

### Masking Tape
Cut or torn masking tape can be used to protect your paper when using watercolors.

### Templates
Watercolor over a template leaves an interesting texture when the template is removed.

### Sandpaper
Sandpaper used on watercolor.

### Opaque Paint
Spatter opaque paint over wet watercolor.

### Alcohol or Water
Alcohol or water can be spattered on damp watercolor and lifted with tissue.

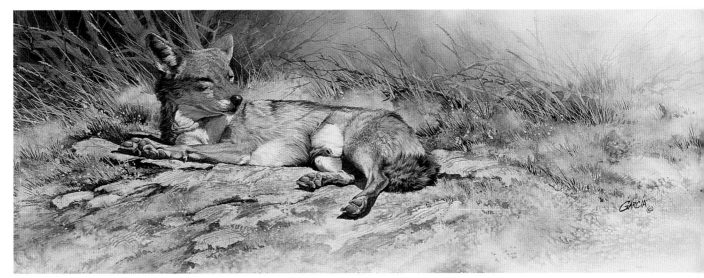

### Combining Techniques

I began the animal with a series of wet-into-wet washes, darkening the values as I went. The background is filled with experiments. I masked out the limbs in the background with masking fluid. I painted the grass and background at the same time with a wet-into-wet wash. The texture of the grass is created with salt. The foreground rocks are created using the edge of a palette knife. I spattered various areas with opaque paint for additional texture. The masking agent was removed and a wash was glazed over this area to push it into the background.

*Lazy Days*
Watercolor on 140-lb.
(300gsm) cold-pressed Arches
10" x 29" (25cm x 74cm)

## Creative Uses of Washes and Textures

The combination of washes and textures is endless. As the artist I have the choice of what to use to make my painting work. Composition, color, value and technique play an important role in its success. Before I start a painting I study the subject carefully. I decide what washes and textures will effectively convey my ideas. Several methods will create a similar texture. A sponge, crinkled paper towel or plastic wrap might all work for the desired texture. Your choice of techniques is what makes your work stand out from another artist. Remember that imagination and creativity will be the catalysts to make your knowledge work.

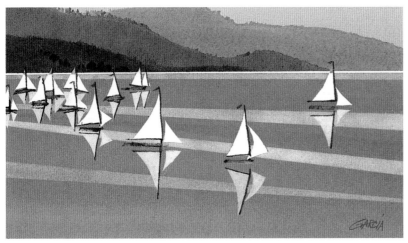

### Masking Tape

Masking tape can be used as a resist. The sails, diagonal areas and the mountains were created using masking tape. Burnishing the tape prevents water from seeping under the tape. If loosely applied, water can penetrate the tape, creating different effects.

*Sail Away*
Watercolor and masking tape on 140-lb.
(300gsm) cold-pressed Arches
5" x 9" (13cm x 23cm)

# Creating Texture on Illustration Board

Illustration board is a good surface to work on. I make sure it is acid-free and then paint on it as I would watercolor paper. Because it is a board it will stay flat and not buckle when wet. It may be purchased with a hot-pressed or cold-pressed surface. Illustration board is very white and because it is less absorbent than watercolor paper, the pigment lifts easily from the surface. It is not as textured as watercolor paper and also works well with pencil or pen and ink. It is a very versatile surface.

Keep a file or notebook of the samples. Start with the basic washes and colors. As you experiment with textures add these to the file. Include the different papers you use. It is an interesting and easy way to keep track of your samples.

## Study Art You Enjoy

It is important to find artwork you enjoy. Study it. Why are you drawn to it? Is it composition, style or technique that make it successful for you? The answer may never be found unless you analyze the work and try another similar painting. Do not feel you are copying, but experimenting and trying to make your work more successful. The answer to your questions may be as simple as the change of weight or brand of paper. You do not know until you try. Paper can have a great influence on the success of your painting. An inexpensive student-quality paper will make painting very difficult. It will not stand up to rough use and will buckle excessively when wet. Generally, this paper is not of archival quality.

**Wet-Into-Wet**
Wet-into-wet watercolor wash on no. I cold-pressed Crescent illustration board.

**Gesso**
Watercolor on no. I cold-pressed gesso-treated Crescent illustration board.

**Transparent and Opaque Watercolor**
Transparent and opaque watercolor on no. I cold-pressed Crescent illustration board.

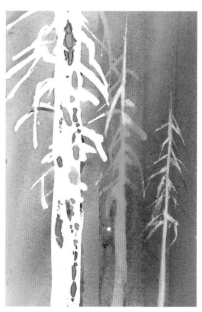

**Masking Fluid**
Masking fluid and watercolor applied to no. I cold-pressed Crescent illustration board.

### Experiment With Wet-Into-Wet

This experiment was not painted to look like anything in particular. I started with a wet-into-wet wash on illustration board. I wanted to experiment with textures. I used salt, spattered water and opaque paint. I had to quit before I had a painting on my hands!

*Variety of Textures*
Watercolor, opaque paint and salt on no. 1 cold-pressed Crescent illustration board
5" x 9" (13cm x 23cm)

### Texture Created From Gesso

*Cattails* was painted on gesso-treated illustration board. I brushed the gesso on with a bristle brush so the brushstrokes would leave a texture. After the gesso dried thoroughly I painted the cattails. I used a wet-into-wet technique, leaving the outside edge white. The background is a wet-into wet gradated wash. This change in value and color saturation is a good way to let the texture of the gesso show through. After all was dry, I took a small bristle brush and scrubbed the white edge of the cattails to soften the boundary between the background and subject. Gesso-treated illustration board is an enjoyable surface to paint on and everyone should try this "trick" at least once.

**Cattails**
Watercolor on no. 1 cold-pressed
gesso-treated Crescent illustration board
5" x 9" (13cm x 23cm)

# Creating Texture on Synthetic Paper

YUPO is interesting to work with. It is a very white nonabsorbent synthetic paper. The pigments stay on the surface and are very intense. It creates a lot of textures on its own and can be tricky to use. I thought it might work well with gesso. When the gesso dried and I painted over the surface, the gesso began to lift. I forgot it could not adhere or soak into the surface. Experiment—you never know what you will learn.

## Experiment for Success

I read an article on watercolor that said "tricks" such as salt, alcohol, etc., were to be avoided. The author said that a watercolor should be a transparent painting using traditional methods to capture an image or idea. Boring! I believe an artist should do whatever it takes to make a successful painting. Tradition is great, but can shut the door on innovation. I taught a workshop and asked the students to experiment and complete a sheet of textural samples. All were good, using techniques that might be expected. Sponge, palette knife and salt were among the favorites. The youngest student, a teenager, presented her sheet and left everyone in silence. Textures ranged from sand glued to the paper, coffee grounds, crayon, bicycle tracks—I could go on. Not all the samples were usable or permanent, but they were creative. She was the hit of the class and let everyone know that they had not even scratched the surface of what could be done.

**Wet-Into-Wet**
Wet-into-wet watercolor wash on 180-lb. (385gsm) YUPO.

**Gesso**
Gesso and watercolor on 180-lb. (385gsm) YUPO.

**Salt**
Salt and watercolor on 180-lb. (385gsm) YUPO.

**Masking Fluid**
Masking fluid and watercolor on 180-lb. (360gsm) YUPO.

## YUPO Paper

*Music Man* was a total experiment. I had seen paintings and read articles about YUPO, a synthetic paper, but had never used it. The quality that intrigued me was the way the paint layered on the surface. YUPO is nonabsorbent, allowing you to lift the paint to the white of the paper. If you do not like your painting, put it under the faucet and wash everything off. The paper will be as good as new. I also used colored pencils and opaque paint on *Music Man*. Try a sheet of YUPO. It was fun and creative. Remember, if you do not like the painting you can "wash your troubles away!"

**Music Man**
Watercolor, Prismacolor and opaque paint on 180-lb. (385gsm) YUPO
7" x 13" (18cm x 33cm)

## Plastic Wrap and YUPO

What is it? Use your imagination. I see ice on a window or river's edge. I used plastic wrap on still-wet, painted YUPO. This is a nonabsorbent surface. The plastic wrap worked well.

**Plastic Wrap**
Watercolor on 180-lb. (385gsm) YUPO
5" x 9" (13cm x 23cm)

# *Format*

You have learned the basics, practiced technique and experimented with texture. Now there is one more thing to consider—format. The definition of format is the general plan or arrangement of something. For the artist, this refers to the layout or composition of the painting. It says nothing about using standard shapes or sizes. The subject and composition should dictate the format. Standard sizes should not be ignored. They offer certain benefits, especially to the beginning painter. Standard-sized paintings can be less expensive to frame. Packing, shipping and storage can be easier to manage. The layout is familiar and easy. However, do not get trapped by standard sizes. There is no rule that says a painting cannot be any size, shape or dimension.

Be creative with formats. Try new ideas. Look at ordinary subjects in a fresh way. Part of learning is exploring and taking chances. Growth should be a constant ingredient of your work. All these ideas sound good, but how do you apply them to your artwork? With repetition you will learn to do a wash perfectly. With practice, color can be mastered. Creativity and imagination are elusive and must be practiced everyday. Study other artists' paintings and ask questions. Keep your mind open to change and try other people's ideas. You may find something that works for you!

**Yellow Lanterns**
Watercolor on 300-lb. (640gsm)
cold-pressed Kilimanjaro
11" x 8" (28cm x 20cm)

### *A White Background Accents the Subject*

*Yellow Lanterns* was painted using the white paper to dramatize the color and composition. The white eliminated all unnecessary information. The lanterns are flat washes of Aureolin Yellow and New Gamboge. The dark robe is a wet-into-wet wash with lifting to show the folds. The white background is the supporting actor who is there to assist the star.

## Composing With the White of the Paper

*Fire Hydrant No. 1* was painted for a concept and not for the subject. This painting is about the design of the rectangular shapes and the negative white spaces. The negative white shapes become a strong compositional element in the painting. It is the concept, not always the subject, that is important. Flat washes are used for the rectangular shapes. A light flat wash was used for the fire hydrant. Color is not a great concern.

**Fire Hydrant No. 1**
Watercolor on 140-lb.
(300gsm) cold-pressed Arches
9" x 7" (23cm x 18cm)

## A Long, Vertical Format

A good part of a nuthatch's life is spent upside down looking for grubs and insects. I felt the use of a tall, vertical format would dramatize the bird's precarious perch. A gradated wash was used in the background to accent this feeling. The lichen is a wet-into-wet wash, with the shadows and texture drybrushed on lantern. The bark was painted with a dry-brush technique. The trunk and branches help compose the long, vertical format.

**A Different View**
Watercolor on 300-lb.
(640gsm) cold-pressed Arches
32" x 11" (81cm x 28cm)

### Breaking the Background

*An Udder Painting* shows an alternate approach to breaking a rectangular format. Attention is drawn to the bovine because her lower half is standing outside the rectangular format of the barn. This technique emphasizes an area or center of interest that might get lost in a busy background. The red wood of the barn is a flat wash of Alizarin Crimson and Brown Madder. The texture on the wall is a dry-brush technique. The dark pattern of the cow is a wet-into-wet wash with lifting.

**An Udder Painting**
Watercolor on 300-lb. (640gsm)
cold-pressed Kilimanjaro
6" x 13" (15cm x 33cm)

### Use the Format to Emphasize the Motion

A long, horizontal format was an effective way to accent the cast of the fly fisher. The wet-into-wet wash created the rising mist. The reflection and weeds along the bank are a salt texture. This scene can be painted in a variety of colors to catch different moods. Use the long, horizontal format to emphasize motion or direction.

**First Cast**
Watercolor on 140-lb.
(300gsm) cold-pressed Arches
5" x 18" (13cm x 46cm)

## Late Night Delivery

I told a client that I would deliver a painting at 8:00 A.M. the next day. I worked all night and finished at 5:00 A.M.. A couple of hours sleep would not hurt, so off to bed I went. At 7:00 A.M. I staggered out to have a final look at my masterpiece. Was I surprised! Our young kitten had decided to add a touch of its own to my artwork. He walked through my wet palette and made a quick trip to my painting. His signature was apparent! My client did not understand my explanation of innovative textures or broken formats. My thoughts about exploring new ideas and creative design elements fell on deaf ears! I went home and started over.

### Break the Edges of Standard Formats

*Daffodils* breaks all four edges of the rectangular format. The rectangular shape creates a feeling of three-dimension. Use colors and values that complement the subject matter. The dark values develop an illusion of depth. There is no rule that says you must paint within traditional formats. Be aware of balance and intersecting lines where the subject breaks the edge of the format. These lines must not create unwanted focal points. Also be aware of the shapes that are created inside and outside the format. A very wet-into-wet cool wash is used in the background. Try this painting using greens for the background. The flowers are painted with a flat or gently gradated wash. The white of the paper is an important design element of this painting.

***Daffodils***
Watercolor on 300-lb. (640gsm)
cold-pressed Kilimanjaro
7" x 3" (18cm x 8cm)

# Traveling with Watercolors

When I travel I often take watercolors and oil paints. Each medium has certain advantages in its application. If I make a list of advantages, watercolors win out. But for some reason I keep bringing my oils along! If I have limited luggage space, watercolors are ideal. A few brushes, a palette with plenty of paint, and paper are all I need. The paper can be individual sheets cut to any desired size, watercolor blocks or watercolor sketchbooks. I can fit this into a briefcase, backpack or suitcase with very little problem.

## Travel Supplies

*Brushes*
   Flats:
      1-inch (25mm)
      ¾-inch (19mm)
   Rounds:
      Nos. 2, 4 and 6

*Other*
   Bug spray
   Erasers
   Good attitude (should
      be number one on
      the list!)
   Hat
   Masking tape
   Paint—bring extra
   Palette
   Palette knife
   Paper or watercolor
      sketchbook
   Paper towels or tissues
   Pencils
   Ruler
   Sketchbook
   Stool
   Sunblock
   Tote bag
   Trash bag
   Umbrella
   Water

If I have space I prefer to travel with additional equipment. The palette I use in my studio and travel with is the Pike Palette. It is a strong, rigid palette with a cover that fits snugly over the pigments. It has a large working area with individual wells to keep the colors separate. The palette and five or six brushes rolled into a bamboo mat start the list of equipment. I use 1-inch (25mm) and ¾-inch (19mm) flats, and nos. 2, 4 and 6 rounds. Various sizes and kinds of paper or a watercolor sketchbook, water, paper towels or tissues, pencil and a tote bag add to the list if room (or memory) allows. I bring a hat, stool and water container. It seems like a lot of equipment, but almost all will fit into the tote bag. Appropriate clothing, sunblock and bug spray won't hurt either. Comfort is essential to success, so be prepared. My motto, "Practice, practice, practice," just sounds good!

Painting while you travel is a memorable way to record your trip. A stack of sketchbooks is a wonderful legacy to leave behind. Each trip will have a story or event that gets more dramatic with the passing of time. However, unlike the fisherman whose fish gets three inches longer and two pounds heavier with the recounting of his catch, my stories are never that way. The sketchbook tells all and keeps things in perspective.

The last time I was painting with an artist friend, we had found our motif and set up. After about fifteen minutes I noticed he was spraying a large circle of bug spray around his area. I asked what he was doing, and he replied that he had unknowingly set up among a colony of red ants. He really liked what he had started and did not want to relocate. A couple of hours later I was finished, so I packed up and began walking back to the car. As I passed by my friend, he mentioned he needed a few more minutes to finish. I looked down and saw millions—maybe billions—of red ants scurrying about in anticipation of his retreat. I waited in the car with the door locked.

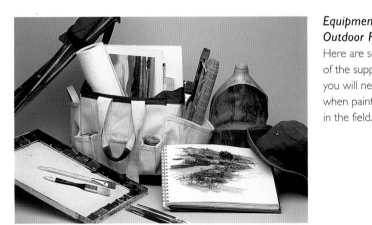

*Equipment for Outdoor Painting*
Here are some of the supplies you will need when painting in the field.

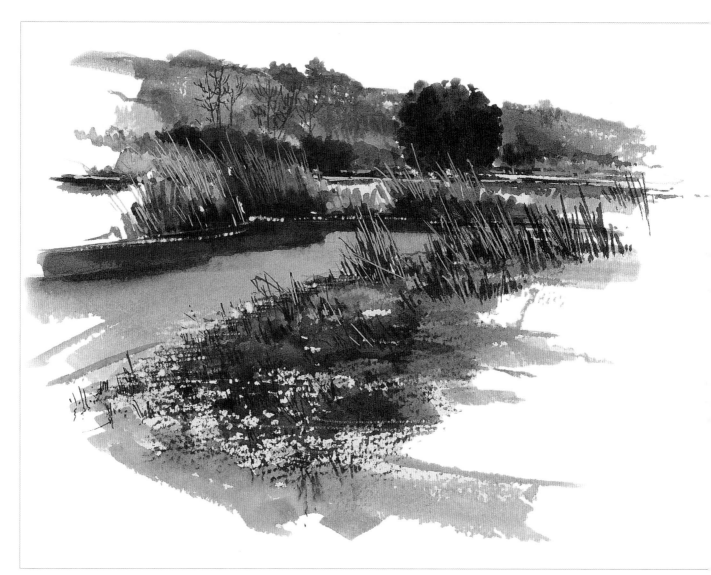

### Painting on Location

*Billy Fields Road* started with a very quick pencil sketch. I used a dry-brush technique so that I could leave a rough, ragged perimeter. While some areas were still damp I used a wet-into-wet wash to add color or value. Some of the reeds were painted using an opaque watercolor. The background was painted using Cobalt Blue, French Ultramarine Blue and Olive Green. In the midground I used Burnt Sienna, Alizarin Crimson, Olive Green and French Ultramarine Blue. I painted the foreground with a wash of mud—a little of everything left on the palette.

**Billy Fields Road**
Watercolor in 80-lb. (170gsm)
cold-pressed Liberte watercolor sketchbook
9" x 10" (23cm x 25cm)

## Painting in Changing Light

Giverny, France, sits on the edge of a hillside overlooking a very quiet, pastoral valley. I borrowed a metal chair from my bed-and-breakfast lodging, and walked down the cobbled lane to paint near the River Epte. This is the same stream from which Monet routed canals to feed his famous Japanese gardens. It was a typical cold, misty December day. As I sat sheltered from the elements under the limbs of a large old tree, I wondered who had painted there before me. The passing rain clouds caused the dim sunlight to constantly change, and therefore the lighter values of the scene were lost, leaving only dark values. I mixed some Pelikan Graphic White into my transparent colors and re-established the lighter values in the fields. The water was painted as a wet-into-wet wash. After this area dried I used some opaque colors.

### The Valley of Giverny
Watercolor on 140-lb. (300gsm)
cold-pressed Arches watercolor block
10" x 7" (25cm x 18cm)

## Capturing the Beauty of Nature

A number of artists met at the Grand Canyon to paint and swap stories. With special permission we were given access to areas not open to the public. Shoshone Point was such an area. Sitting at the edge of the canyon I could hear the ravens' wings cut through the air. I started painting *Shoshone Point* with very light wet-into-wet washes. I used Burnt Sienna, New Gamboge and Cobalt Blue to lay in these initial colors. As this area dried, I glazed or washed on stronger and more intense color. For the last step, I glazed the interior of the canyon using a wash of a Cobalt Blue and Alizarin Crimson mixture. At the bottom area I used a dry-brush technique for the broken-edge texture to carry the viewer into the painting. You do not have to fill the painting area edge to edge.

### Shoshone Point
Watercolor on 140-lb.
(300gsm) cold-pressed Arches
14" x 10" (36cm x 25cm)

### Paint What Surrounds You

I enjoy painting on location. *Red-Winged Blackbird* started as a painting with mountains, trees, a lake and cattails. As I sat and sketched, the continual flight of birds caught my attention. I finally realized that I was overlooking the obvious and decided to paint a more intimate setting. I focused on the water, grass and blackbird, who had been letting me know I was in his territory!

I used a lot of dry-brush technique with Cobalt Blue and Alizarin Crimson for the water. The water, grass and reeds are a mixture of Sap Green and French Ultramarine Blue. I did not want to cover the entire surface of the paper, which allowed me to focus on the more intimate setting.

*Red-Winged Blackbird*
Watercolor on 140-lbs. (300gsm)
cold-pressed Arches watercolor block
5" x 7" (13cm x 18cm)

## Traveling With Watercolors

Watercolors are a convenient way to paint when traveling. A small palette, a few brushes and paper are easily packed away. They are light and nonflammable. When I reach my destination, less time is used setting up to paint and the watercolors dry fast. However, when traveling with my oil paint equipment I never know what to expect. Customs officials have dismantled my French easel. They have opened tubes of paint which are then sniffed by their drug-sniffing dogs. Turpentine cannot be taken onto the airlines, and buying it in other countries is not easy when nobody speaks English. My rental car has had oil stains from dashboard to trunk. I have driven hours in freezing weather with the windows rolled down to air out the car of turpentine fumes. Also, getting wet oil paintings home can be a real challenge. As I pack my bags and prepare for my return, I know the drug-sniffing dogs will be waiting. Watercolors are not a bad way to travel!

### Paint From the Best Vantage Point

The village of Mendocino, California, is famous for its Victorian charm. I painted a watercolor study from a small cove below the village. Wet-into-wet washes of Olive Green, Sap Green and Burnt Sienna are used for the foliage. After this area dried, the dark shadows were painted with a mixture of a Sap Green and French Ultramarine Blue wash. The cliff, beach and buildings were painted with Burnt Sienna and Raw Sienna. The shadows on the cliffs are a mixture of Cobalt Blue and Alizarin Crimson. The sky is a wet-into-wet wash of Cobalt Blue and Cerulean Blue.

*Village of Mendocino*
Watercolor on 140-lb. (300gsm)
cold-pressed Arches watercolor block
6" x 9" (15cm x 23cm)

# Painting Studies on Location

Location paintings do not have to be final pieces of art. They can be studies to isolate and describe a particular subject. I do this if time is short or weather is turning bad. Also, at a later date I may want to combine a number of elements from different areas into one painting.

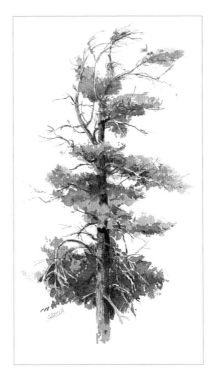

### Paint Unique Shapes From Nature

I painted this old ponderosa pine because the tree had such character. It had seen better days and now had many dead and broken limbs. I liked the shape of the tree with all the negative and positive shapes that its structure had created. I used a dry-brush technique to paint the foliage. The colors are Olive Green, Sap Green, Cobalt Blue and in the dark areas, a touch of Burnt Sienna was added. I used a mixture of French Ultramarine Blue, Burnt Sienna and Brown Madder for the trunk and limbs.

*Old Ponderosa Pine*
Watercolor on 80-lb. (170gsm)
cold-pressed Liberte watercolor sketchbook
10" x 9" (25cm x 23cm)

### Find Contrast When Painting Outdoors

This setting made me think about what an old homestead should look like. All the outbuildings were old and well used. The very dark blue background was what first caught my attention. The sun broke through the clouds momentarily and bathed the buildings in bright, crisp light. The contrast was memorable. The foreground and trees were painted with Olive Green, Sap Green, Burnt Sienna and Cobalt Blue. The dark background was a wet-into-wet mixture of French Ultramarine Blue and Cobalt Blue.

*The Homestead—Study*
Watercolor on 140-lb. (300gsm)
rough Arches watercolor block
5" x 7" (13cm x18cm)

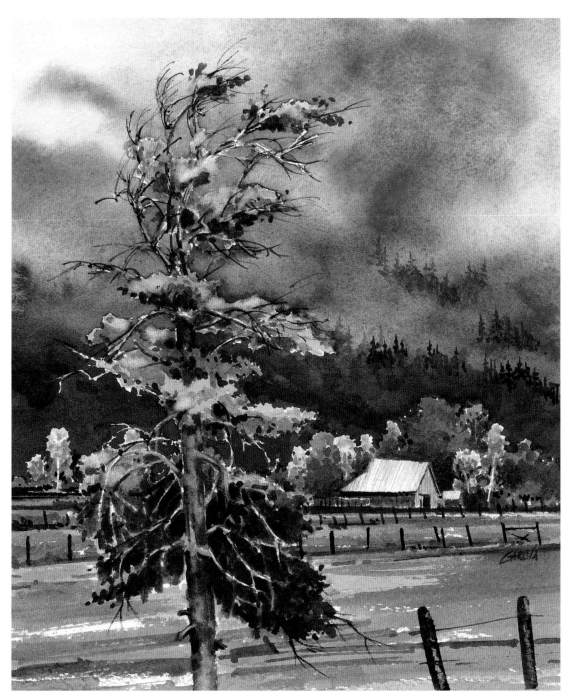

### Combine Elements Found on Location

In my studio I combined the old ponderosa pine and the outbuilding to create a vertical format. I did this to accent the approaching storm as it entered the valley. The greens I used were Olive Green and Sap Green with Burnt Sienna added. The dark blue background is French Ultramarine Blue, Cobalt Blue and a little Brown Madder. This area was a very wet-into-wet wash.

*The Homestead*
Watercolor on 140-lb.
(300gsm) cold-pressed Arches
7" x 6" (18cm x 15cm)

# Conclusion

"A journey of a thousand miles must begin with a single step."—Lao-tzu, from *Way of Lao-tzu*.

This is so true for any artist. Mastering the watercolor wash is a journey in its own right. From the first learning brushstrokes to the final signature, an artist must set a direction. A successful wash is only one aspect of this expedition. A working knowledge of color, composition and value are also needed to complement this journey. Flat, graded and wet-into-wet washes are the physical washes for painting. They are the starting point. *Mastering* them can be a misnomer. An *elusive conquest* might be a better way to describe painting these washes.

The reasons for painting are as personal as the style and technique you choose. There is no right way or wrong way, only different ways to paint. Let each painting be a new experience. Aspire to be a storyteller. If you do this the artist part will take care of itself.

Practice, practice, practice," is the mantra for success. With success comes confidence. *Mastering the Watercolor Wash* is meant to give you a starting point, not a conclusion. Set a series of goals. When one is reached have another one to replace it. As your painting skills improve your goals

should be more difficult to attain. As time passes you will find that ideas become more important in each painting. Your painting skills will be used to tell a story.

Compare and exchange ideas with friends and fellow artists. Use books and magazines as reference tools. Use the paintings and demonstrations in this book to help develop your skills. Colors and subjects can be changed;

skills are the foundation. If you become discouraged it is often because you are trying to do too much, too soon. There are no shortcuts to becoming an artist. Take a step-by-step approach and there will be fewer bumps to cross over. Lift your brush and let the journey begin.

*Piwakawaka*
Watercolor on 140-lb.
(300gsm) cold-pressed Arches
6" x 29" (15cm x 74cm)

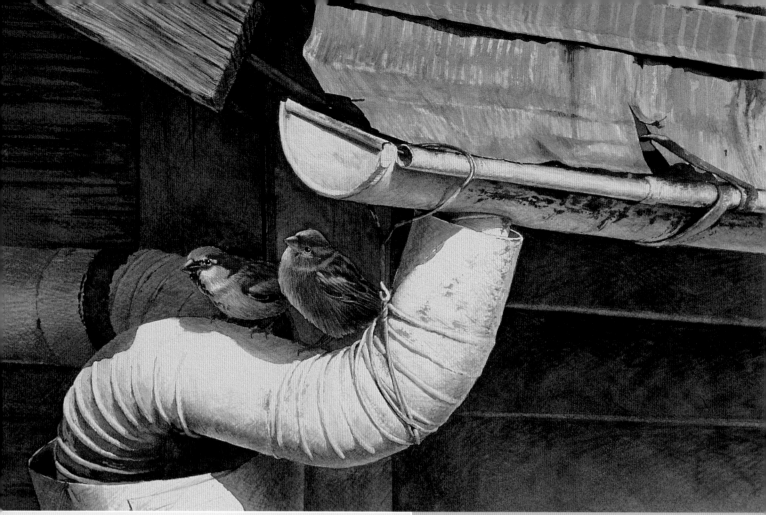

# Glossary of Terms

Bristle—Hog's hair brush used to lift out color or soften an edge that has become too hard.

Chisel—Flat brush, used for washes or glazes.

Cold-Pressed—Paper dried with pressure, but no heat to create a medium-textured paper.

Dry Brush—Painting on a dry surface using a brush containing paint with very little moisture in it.

Flat Wash—A standard wash, all the same value and color. Not much variety in tone or texture.

Graded Wash—One which goes from light to dark or dark to light in value.

Gum Arabic—Form of glue used in watercolor to bind the pigment together.

Hard Edge—Very distinct line (edge) created where two values meet.

Hot-Pressed—Paper dried under heat and pressure to create a very smooth surface.

Hue—Any color or graduation of color.

Lifting Color—Methods in which brushes, paper towels or tissues are used to remove a hue or soften an edge.

Opaque—Not transparent or translucent paint.

Rag Paper—Bleached or unbleached cotton fibers made into a "soup" poured over a screen and, by the process of the individual paper maker, transformed into a sheet of paper.

Ream—The weight of 500 sheets of a particular paper. Standard watercolor paper weights are 90lb. (190gsm), 140lb. (300gsm), and 300lb. (640gsm).

Rough—Much texture on the surface of the paper.

Round, Pointed—Round large brush used for washes or glazes, small used for detail.

Saturation—The amount of pigment used in a wash. 100

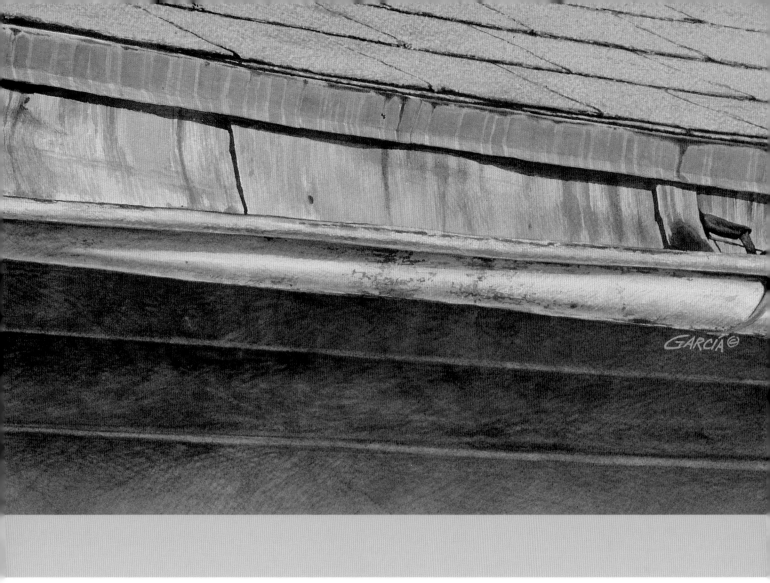

percent saturation is the color or hue being used at its strongest value.

Sizing—A starch used on the surface of many watercolor papers.

Starved Palette—Too much water, not enough pigment in the wash.

Streaked Wash—Clear water is placed on the surface of the paper. While the paper is still very wet, the pigment is placed at the top and one corner of the sheet is picked up, allowing the color to flow in the desired direction.

Stretched Paper—Method of soaking paper, then attaching it to a flat surface and allowing it to dry and shrink, creating a very flat surface on which to paint.

Tooth—The amount of texture on the surface of watercolor paper. The three basic grades of paper used in watercolor painting are: cold-pressed, hot-pressed and rough.

Wash—Passage of fluid color, usually applied rapidly over a large area.

Watercolor—Any pigment soluble in water, either opaque or trans-parent, and the painting executed with water.

Watercolor Block—Watercolor paper bound on all four sides, usually in 90-lb. (190gsm) or 140-lb. (300gsm) weights.

Wet-Into-Wet—Color brushed onto surface of the paper that is already wet.

**House Hunting**
Watercolor on 140-lb.
(300gsm) cold-pressed Arches
11" x 29" (28cm x 74cm)

# Index

Take advantage of the transparent, fluid qualities of watercolor to create startling works of art that glow with color and light! Jan Fabian Wallake shows you how to master special pouring techniques that allow pigments to run free across the paper. There's no need to worry about losing control or making mistakes. Wallake empowers you to trust your instincts and create glazes rich in depth and luminosity.

ISBN 1-58180-161-0, hardcover
128 pages, #31910-K

Paint more lively, inspiring landscapes with the creative use of reference photos— where magical moments of light are frozen in time and gorgeous winter vistas can be painted from the comfort of your own studio. Dozens of examples and step-by-step demonstrations show you how to shoot good reference photos, then crop, modify and combine elements from each for stunning landscape paintings of your own design.

ISBN 1-89134-973-1, hardcover,
128 pages, #31524-K

Charles Reid is one of watercolor's best-loved teachers, a master painter whose signature style captures bright floral still lifes with a loose spontaneity that adds immeasurably to the whole composition. In this book, Reid provides the instruction and advice you need to paint fruits, vegetables and flowers that glow. Step-by-step exercises help you master techniques for painting daffodils, roses, sunflowers, lilacs, tomatoes, oranges and more!

ISBN 1-58180-027-4, hardcover,
144 pages, #31671-K

Overcome the elusive challenge of rendering realistic skin tones in your portraiture. Whether your subject is Caucasian, Asian, African-American or Hispanic you will find practical guidance on how to successfully depict each one's distinct beauty. Lessons and demonstrations in oils, pastels and watercolors teach you how to mix colors, work with light and shadow and edit your compositions for glowing portraits you'll be proud of.

ISBN 1-582-180-163-7, hardcover,
128 pages, #31913-K

These books and other fine North Light titles are available from your local bookstore, online supplier or by calling 1-800-221-5831.